IMAGES
of America

EARLY SNOHOMISH

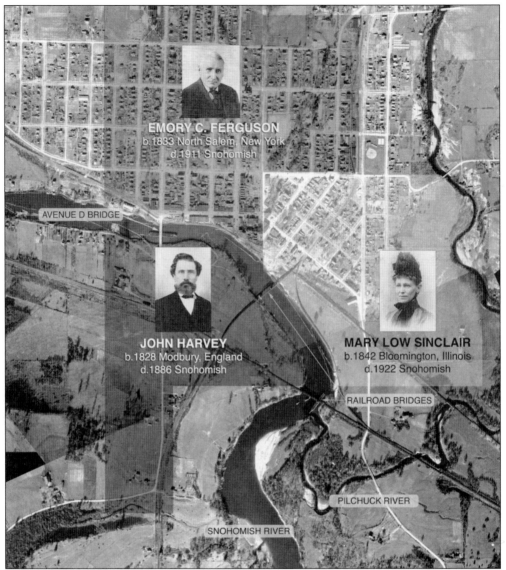

AVENUE D BRIDGE

EMORY C. FERGUSON
b.1833 North Salem, New York
d.1911 Snohomish

JOHN HARVEY
b.1828 Modbury, England
d.1886 Snohomish

MARY LOW SINCLAIR
b.1842 Bloomington, Illinois
d.1922 Snohomish

RAILROAD BRIDGES

PILCHUCK RIVER

SNOHOMISH RIVER

FOUNDING SETTLERS OF SNOHOMISH, 2007. The author has overlaid a 1938 aerial photograph with information about the settlers of the initial squatter claims that became Snohomish. Both E. C. Ferguson and John Harvey arrived in 1859, while Woodbury and Mary Low Sinclair purchased the Edison Cady claim in 1865. (Blake, Kiblinger.)

ON THE COVER: The unknown photographer stood on the new railroad bridge over Snohomish River c. 1890 to get this view. On the left, the south side of the river, is the Cascade Shingle and Lumber Mill. Barely visible is the first Avenue D Bridge, which pivoted to allow for steamships—the only element missing from this popular image of early Snohomish. (Snohomish Historical Society, FS-026.)

IMAGES
of America

EARLY SNOHOMISH

Warner Blake

ARCADIA
PUBLISHING

Published by Arcadia Publishing
Charleston SC, Chicago IL, Portsmouth NH, San Francisco CA

Printed in the United States of America

Library of Congress Catalog Card Number: 2007923091

For all general information contact Arcadia Publishing at:
Telephone 843-853-2070
Fax 843-853-0044
E-mail sales@arcadiapublishing.com
For customer service and orders:
Toll-Free 1-888-313-2665

Visit us on the Internet at www.arcadiapublishing.com

To the memory of the founders of the Snohomish Historical Society:
Gladys Bailey
Lois Brown
Ione Gale
Everett and Mary Olsen
Lilas Price
Milton Perman

And for the founders who are still with us:
Bill and Barbara Bates
Middy Ruthruff

CONTENTS

ACKNOWLEDGMENTS

Topping this list of thanks are Victoria Harrington, Snohomish Historical Society photograph archivist and restorer of several images used here; Donna Harvey, archivist and family historian; Ann Tuohy, archivist and indexer of this book; and Middy Ruthruff, archivist and guide to the society's very helpful collection of family and business histories.

Margaret Riddle and David Dilgard established the Northwest Room at the Everett Public Library 30 years ago; their help with this project has been indispensable. David's knowledge of Snohomish history has left me realizing how much more there is yet to learn.

Nicolette Bromberg, visual materials curator for the University of Washington Libraries, Special Collections, helped me locate the portrait of Mary Low Sinclair, for which many of us in Snohomish are very grateful. A quiet shout of thanks is due the patient staff.

Carolyn Marr, librarian at the Museum of History and Industry in Seattle, solved the mystery of Asahel Curtis being credited for a photograph taken the year he arrived from Minnesota with his parents.

Thanks to Snohomish Branch of Sno-Isle Libraries for its open access to the first newspapers of Snohomish.

Thanks to Maurice DeLoy for sharing his mother and aunt's album from their days as housekeepers at the St. Michael's Rectory.

Tom Hamilton provided the lowdown on early ballooning.

Allison Merrill, who did not have a famous author's book to proof (her day job), graciously agreed to give this effort a professional read. Other readers were Bill and Barbara Bates, Victoria Harrington, Donna Harvey, and Gary Ferguson.

At the bottom of the list, but always first in my thoughts, is Karen Guzak, whose big idea it was to buy our old church. So what choice did I have but to learn its context within the history of early Snohomish?

A note about image labels: Following the title is the date of the photograph if one is available. Following the caption, the last name of the photographer (if known) and the lending institution are listed (abbreviated after its first appearance), along with the collection number. Image numbers standing alone are from the Snohomish Historical Society, PO Box 174, Snohomish, WA 98290.

INTRODUCTION

Snohomish's first recorded reflection of herself as a place of historical interest is a 1939 *Snohomish County Tribune* editorial supporting the call for a museum of pioneer relics within the city. One year earlier, however, the same editorial page had spoken in favor of the school district's demolition of the 1890 courthouse in order to make room for a new high school.

Fourteen years later, in 1953, Emma Patric, with the women's Cosmopolitan Club, told the *Tribune* that she had the mayor's support for a historical society building. In fact, he had selected the north side of the Carnegie Library grounds as a tentative site and suggested that the collection include an old steamer-type fire engine and a one-horse shay, two of his favorite items. Patric told the city council that such a project would spur tourist interest and that the building could be used as an air raid shelter. Having captured their attention, she explained that the earth excavated from the basement could be used to fill the Glen Street gulch.

It never came to pass. People's cold war paranoia softened, while the downtown shops migrated north and east, settling in surrounded by the comfort of easy parking. Secondhand stores filled in, and to generate shopping interest, merchants took to calling Snohomish "the Antique Capital of the Northwest."

In the late 1940s, an automobile dealership on the south side of First Street collapsed down the hillside, toward the river, its foundation compromised by continued flooding. This led to the eventual removal of all the unsafe, abandoned buildings between Avenues B and C, replaced with a riverside park. Perhaps this is what inspired a Seattle architect in 1965, with urban renewal funding, to recommend removing even more of the buildings on the south side of First Street and then update the remaining buildings to give Snohomish the look of a riverside shopping mall. A unique feature of this scheme is that the active lumber mill across the river would have dominated the visual and aural landscape of the shoppers. An editorial on October 28, 1965, claimed, "Snohomish hasn't sunk that low, yet."

On November 4, 1968, a group of citizens met at the public library for the purpose of establishing a historical society, which would purchase the Hyrcanus Blackman house (1878). Thanks to the generous terms offered by the Blackman family, since relocated to California, and the willingness of the first historical society president, Everett Olsen, to cosign the loan, a deal was struck. Volunteers managed to redo the first floor of the home, recapturing family life of the 1880s just in time for the society's first Christmas Tea, in 1970.

Before the teacups were air-dried, however, the members were on to their major goal—to have the core of Snohomish listed on the National Register of Historic Places. Following two years of meetings, the election of the first two women to the city council, and the passing of one city ordinance, their goal was met on November 13, 1974. And, spurred on by the enthusiasm of city council member Ione Gale, committee work began on a book about early Snohomish, published two years later. *River Reflections—Snohomish 1859 to 1910*, a liberally illustrated collection of essays, newspaper articles, and personal remembrances, was such a success that it spawned a second volume covering the years 1910 to 1980, published in 1981.

My intention is that this effort will honor theirs. After all, without the foresight, commitment of time, and elbow grease of the society's charter members, there would be no story saved for me to tell here.

The story of Snohomish actually begins in the frontier community of Steilacoom, a five-day boat trip south from the mouth of the Snohomish River. Steilacoom grew in the shadow of a military fort established in 1849 to watch the waters of south Puget Sound for signs of the famous British Navy. Federal funds were available for building a military road from Fort Steilacoom to Fort Bellingham, near the Canadian border, far enough inland to be out of range of British cannons, and this road would need to cross the Snohomish River. Consequently, a group of investors living in Steilacoom, which included Emory C. Ferguson and was led by the future governor of Idaho W. H. Wallace, obtained the franchise to establish a ferry across the river at the site of the road. Their first step was to send three men—Edison Cady, Hiel Barnes, and Egbert Tucker—to stake squatter claims on both sides of the river. In the meantime, military tensions eased and funding for the road was cut, leaving only a rough muddy trail, barely passable on foot. But this did not stop the road's contractors from "proving" that it was passable for wagons by shipping one up the river in parts, along with a team of horses, then reassembling the wagon on the bank of the river. An army official, who arrived by canoe, verified the presence of the horse-drawn wagon and approved payment.

This story, nearly 150 years old, about military contractors defrauding the government, is as fresh as today's headlines. Yet it's convenient to think of the settlers as alien to us, as if they were settlers on another planet, so that even if we were able to go back in a time machine, we would have nothing in common to talk about. I hope this book can help. The joy of assembling the historic images and the memorabilia, even pinning down dates, is the resulting thought experiment, where oftentimes the imagination is the only link to the motivations of the people who made this place.

Looking through the Ferguson papers at the University of Washington Libraries' Special Collections room (which were donated by his daughter Sylvia in the year of my birth, curiously enough), I read a letter from his sister Louise, written on December 2, 1866, from New York State. It begins, "Brother Emory, Another year has nearly fled, and yet you and brother Clark are not any nearer our childhoods' house than you were two years ago." She continues, "I sincerely hope that before the year 1867 shall have passed (if we are permitted to live) that we shall have the pleasure of seeing your faces once more, or at least one of you."

Holding in my hands the same piece of paper that Emory Ferguson held in his to read these words, my imagination is working overtime trying to understand a man who would exchange all that is familiar and comfortable for all that is strange and difficult. The following year, he married Lucetta Morgan from Olympia, and there is no record of brother and sister ever seeing each other again. There is only the one letter from Louise in the folder, and it is in pristine condition. Ferguson had saved it for a long time, inside its envelope addressed to him at "Snohomish City, W. T."

If your imagination is willing, that is where we're going: Snohomish City, Washington Territory.

One

RUMORS OF A
FERRY CROSSING

When the idea of a military road crossing the Snohomish River floated away with their cigar smoke, the Steilacoom investors backed out, except for Emory C. Ferguson, who decided to go ahead with the plan on his own. He was a young carpenter from New York State who landed in Steilacoom after going bust looking for gold in Canada. He pre-built himself a small house in Steilacoom and shipped it north in the spring of 1859. Hiel Barnes, who was holding Ferguson's claim, assembled the house on a site overlooking the river, close to where it still stands today. Ferguson arrived the following spring with enough supplies to stock a store.

John Harvey, barely 10 years in the country from England, had already bought and sold a claim on Lake Washington, near current-day Seward Park in Seattle; fought the Native Americans in the Battle of Seattle; and lost his stock for a store on the Snohomish River to "hostile Indian activities," according to published accounts at the time. But he returned in 1859 to purchase the 160-acre claim held by Egbert Tucker on the south side of the river for $50, including the "shack" he was living in. He began clearing the land to establish a farm.

In December 1860, with the murder of a trading post proprietor downriver, settlers met in Ferguson's small cottage to draw up a request for military protection, which grew into a petition for the establishment of a separate county. Their timing was perfect since a similar petition was already being considered by the territorial legislature in Olympia and was approved the following month. Snohomish County came into existence on January 14, 1861, with both Ferguson and Harvey as commissioners.

The population of settlers in the new county was roughly 49 men and no women. But that didn't last long. Mary Low Sinclair, 22 years old and a new mother, followed her husband, Woodbury, to what she later called the "small clearing in the otherwise unbroken timber," and together they signed the deed to Edison Cady's claim in 1865. And with that, the founding settlers of Snohomish were all in place.

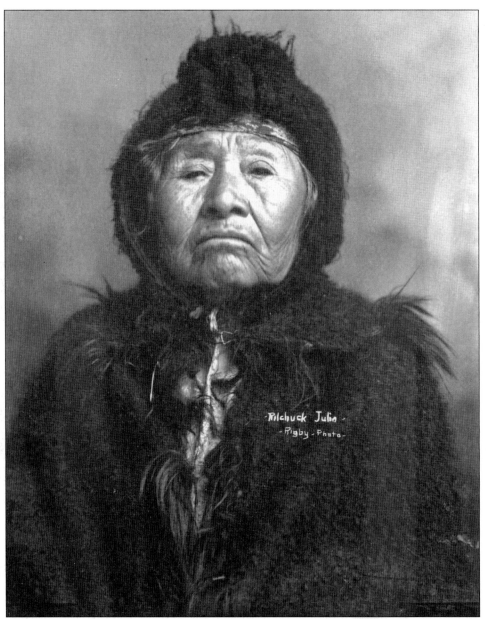

PILCHUCK JULIA, C. 1910. Pilchuck Julia's life spans the history of Washington. She was born in the late years of the Joint Occupancy with England, from 1818 to 1846; beginning in 1848, Washington was part of the Oregon Territory; the boundaries of Washington Territory were established in 1853; and finally, Julia became a resident of Washington State in 1889. In 1920, a reporter from Seattle's *Post-Intelligencer* visited Julia in the company of pioneer community leaders Mary Sinclair and William Whitfield. The resulting article estimated Julia's age to be about 80 years: "She is very energetic, cultivates her garden, fishes in the Pilchuck River, and regularly walks to Snohomish, a distance of nearly two miles." Julia died in 1923. The photographers were Iowa-born sisters Alice and Clara Rigby, owners and operators of a studio in Everett from 1905 to 1915. In 1913, they visited Japan, and shortly after their return, Alice died from cancer, only 44 years old. A few months later, Clara closed the studio for good. (Rigby and Rigby, NA-005.)

NATIVE AMERICAN GRAVE, C. 1885. The Pilchuck Indian community ranged up and down the river valley and was always a small, peaceful group that was made smaller every year by the diseases of the white man. Only the four members shown below remained by the start of the 20th century. (Horton, Snohomish County Museum.)

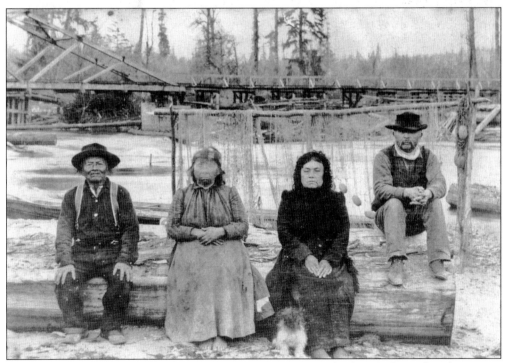

LAST OF THE PILCHUCKS, C. 1910. From left to right are Pilchuck Jack; his wife, Julia; Hattie Jack; and her husband, Peter Jack. When asked if her late husband was a good warrior by a writer from the *Overland Monthly* in 1906, "Julia placed the tips of her fingers on her closed lips as if to say: 'The records of the old days are sealed.'" (NA-038.)

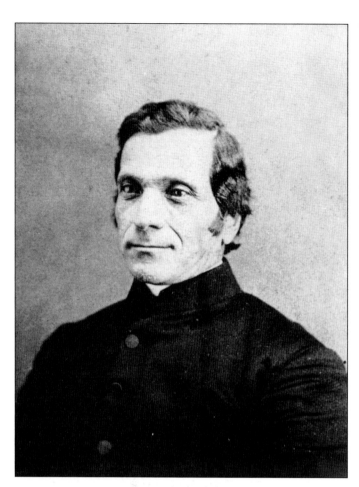

FATHER CHIROUSE. Fr. E. Casimir Chirouse, a French missionary, arrived in 1857 from Walla Walla, Washington, where he had been stationed since 1847. Within three years, the settlement called Priest Point grew to 200 Native Americans, and the mission school enrollment was 15 children. (University of Washington Libraries, Special Collections.)

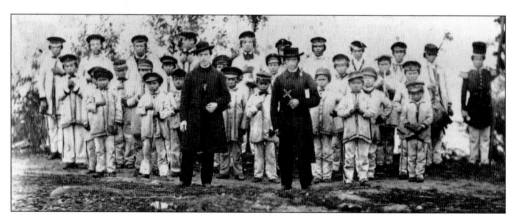

TULALIP STUDENTS, C. 1865. The Tulalip Reservation is located due west from the mouth of the Snohomish River on the shore of Ebey's Slough. In 1869, the federal government entered into a contract with the mission for the instruction and maintenance of the school, making the Tulalip Mission School the first government contract school in the history of the United States. (Robertson, UW, NA 1498.)

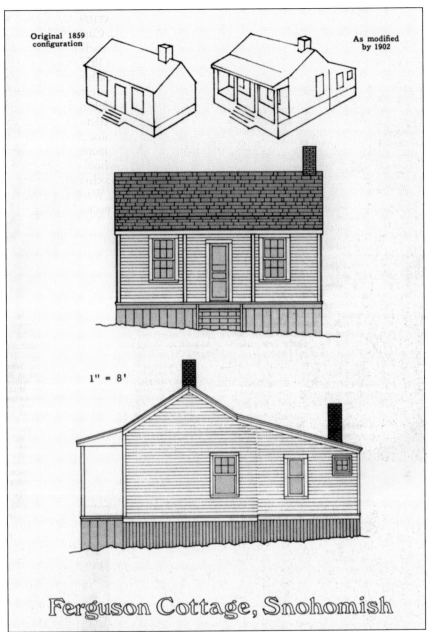

Original 1859 configuration

As modified by 1902

1" = 8'

Ferguson Cottage, Snohomish

FERGUSON COTTAGE, 1981. This small "cottage," as it has come to be called, was the center of county and city business in the new settlement. Five days before celebrating his first Christmas on the river, Emory Ferguson hosted a meeting of his neighbors to draft a request for more military protection from hostile Native American activities. They ended up drafting a petition to the territorial legislature to form a separate county, which they submitted with the new year of 1861. Since this structure still exists, historian David Dilgard was able to measure it, and he made this scale drawing. Ferguson lived in this two-room house, measuring 16 feet across the front by 24 feet deep, for 20 years and later in his life told a reporter, "It wasn't a palace, but it was home sweet home to me for many a year, and I never have been happier than while I lived there." (Dilgard, Northwest Room, Everett Public Library.)

13

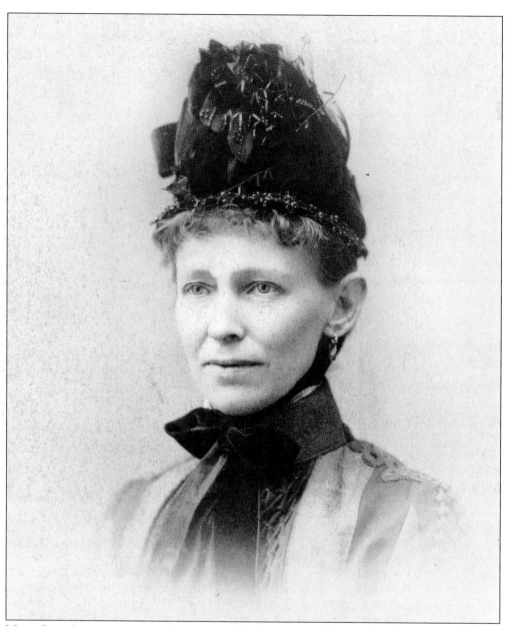

MARY LOW SINCLAIR, C. 1905. Mary Low became a teacher in Port Madison, a bustling mill town across the Puget Sound from Seattle, where she met and eventually married her boss, Woodbury Sinclair, the school district clerk. In 1864, he traveled to "Cadyville" with the intention of establishing a trading post. In May 1865, Mary arrived aboard a slow steamship with their household goods and infant son, Alvin. "As the steamer landed at the gravel bank near the foot of Maple Street," she remembered in 1911, "a small clearing appeared in the otherwise unbroken timber. The store was a 12 by 16 foot shack, without windows, doors, or floor, with living rooms in the back. For two years there was no regular steamer outside, and the only fruit available was wild berries. But living was cheap and good. . . . there was no time to be lonesome." Mary Low Sinclair became the first white woman to make the future Snohomish her home. (LaRoche, UW 26773.)

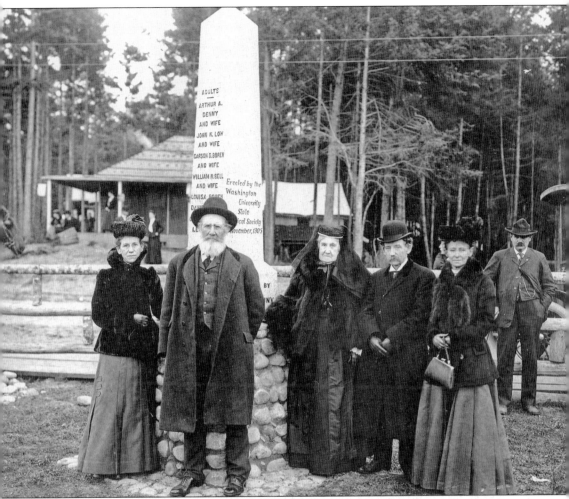

ALKI POINT MONUMENT DEDICATION, PEISER, 1905. An eight-year-old Mary Low left Bloomington, Indiana, with her parents, heading west over the Oregon Trail all the way to land's end at Alki Point and arriving on November 13, 1851—as remembered by the dedication of this monument. Mary is considered the founder of education in Snohomish, offering her home for the first classroom in 1869. Her husband, Woodbury, died in 1872, leaving Mary to manage the business of owning nearly half the Snohomish City site. She began by donating land, first for schools, then a three-acre site for a cemetery to honor the memory of her husband—the first organized burial ground in the county. She died in her home on Pearl Street in 1922, and her passing was noted throughout the state. Mary is on the right in the picture above. With her, from left to right are Lenora Denny, Carson Boren, Mary Denny, and Roland Denny—all family names of the founding settlers of Seattle. (Peiser, UW Peiser 10088.)

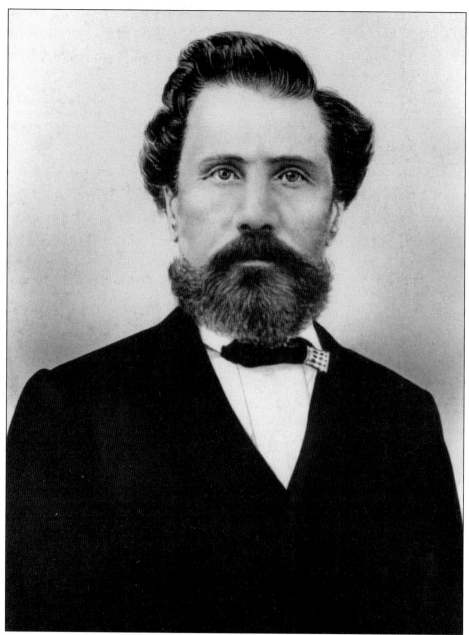

JOHN HARVEY. The settler of the third claim on the south side of the river came from England in 1849. John Harvey was around 20 years old and following a childhood dream. Sailing to San Francisco, then north, he landed at Alki Point some four months after Mary Low arrived with the first group of Seattle settlers. In fact, he worked for Mary's father, John Low, who was logging at Alki. Perhaps this is where he heard talk of a beautiful river country up north and rumors of a ferry crossing. In any event, John Harvey settled a donation claim of 160 acres on what is today Lake Washington, clearing the land and establishing a lakeside farm. It was destroyed in the Indian Wars of 1855, however, in which John was engaged as a "volunteer" soldier. He sold the destroyed claim as soon as he could for $2,000 and headed north to that river valley of opportunity with a backdrop of white-capped mountains. (Courtesy Donna Harvey.)

THE UNITED STATES OF AMERICA,

To all to whom these presents shall come, Greeting:

Homestead Certificate No. 745

APPLICATION 1864 } **Whereas** There has been deposited in the General Land Office of the United States a Certificate of the Register of the Land Office at *Olympia Washington Territory*, whereby it appears that, pursuant to the Act of Congress approved 20th May, 1862, "To secure Homesteads to actual Settlers on the Public Domain," and the acts supplemental thereto, the claim of *John Harvey* has been established and duly consummated, in conformity to law, for the *Lot numbered four of Section eighteen, in Township twenty-eight North of Range six East, and the Lot numbered nine of Section thirteen, and the East half of the North East quarter of Section twenty-four, in Township twenty-eight North of Range five East in the District of Lands subject to sale at Olympia Washington Territory, containing one hundred and sixty-nine acres, and twenty hundredths of an acre* according to the Official Plat of the Survey of the said Land, returned to the General Land Office by the Surveyor General:

Now know ye, That there is, therefore, granted by the United States unto the said *John Harvey* the tract of Land above described: To have and to hold the said tract of Land, with the appurtenances thereof, unto the said *John Harvey* and to his heirs and assigns forever; subject to any vested and accrued water rights for mining, agricultural, manufacturing, or other purposes, and rights to ditches and reservoirs used in connection with such water rights, as may be recognized and acknowledged by the local customs, laws, and decisions of courts, and also subject to the right of the proprietor of a vein or lode to extract and remove his ore therefrom, should the same be found to penetrate or intersect the premises hereby granted, as provided by law.

In testimony whereof, I, *Rutherford B. Hayes*, President of the United States of America, have caused these letters to be made Patent, and the Seal of the General Land Office to be hereunto affixed.

Given under my hand, at the City of Washington, the *second* day of *July*, in the year of our Lord one thousand eight hundred and *seventy-seven*, and of the Independence of the United States the one hundred and *first*.

BY THE PRESIDENT: *R. B. Hayes*

By *B. L. Lang*, Secretary.

S. W. Clark, Recorder of the General Land Office.

Recorded, Vol. 2, Page 445.

HOMESTEAD CERTIFICATE, 1877. A Final Homestead Proof Certificate was prepared by federal inspectors to identify the honest claim holder. This document states that before June 1869, Harvey made settlement on said land and built a two-story house of lumber, "well furnished and a comfortable house to live in." What it does say, however, is that the Harvey homestead was a welcome site to river travelers in those early years. (Courtesy Donna Harvey.)

17

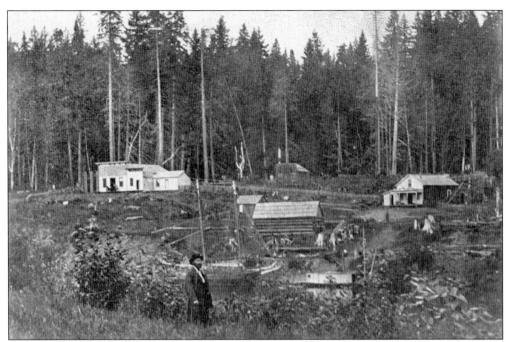

THE COUNTY SEAT, 1865. The first known photograph of Snohomish is attributed to E. M. Sammis, a New York photographer working in Seattle when he took the only studio photograph of Chief Seattle. A newspaper account, in 1865, tells of his trip up the Snohomish River on his way to "Washington Territory's greatest wonder, The Falls of the Snoqualmie." (Sammis, SG-002n.)

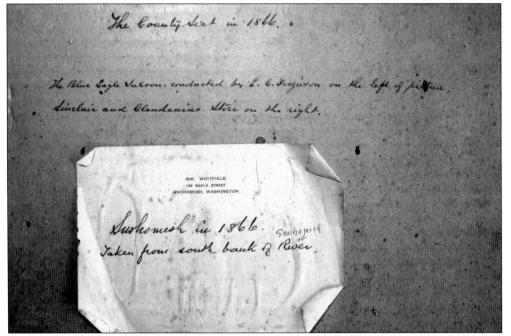

REVERSE OF FRAMED PHOTOGRAPH ABOVE, 2006. The inscription, supposedly in William Whitfield's hand, states: "Snohomish in 1866." However, the date should be 1865 considering current research of the photographer's travels. (Blake.)

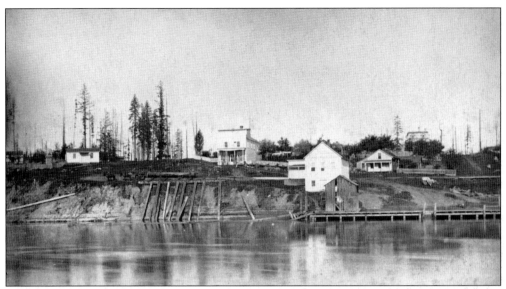

JACKSON WHARF, C. 1885. From left to right are the Ferguson Cottage; the Blue Eagle Saloon, which was also the post office and city hall; the Sinclair store, the largest building, converted into the Riverside Hotel with a large hall on the second floor used for community gatherings; and the Sinclair/Clendenning store, where the Sinclairs spent their first night in their new home. (Horton, Snohomish County Museum.)

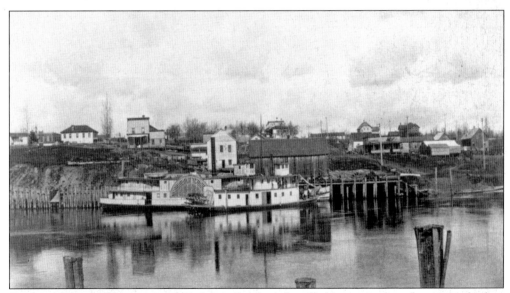

SHEPARD HENRY WHARF, C. 1892. Mary Sinclair's "small clearing in the otherwise unbroken timber" has sprouted buildings and steamship service has multiplied. The stern-wheeler *Florence Henry* is identified, but the side-wheeler next to her is not. At left, at the top of the hill, standing tall, is the famous Blue Eagle Saloon. The road on the right is Maple Street. (Wilse, Museum of History and Industry [MOHAI], No. 11,007.)

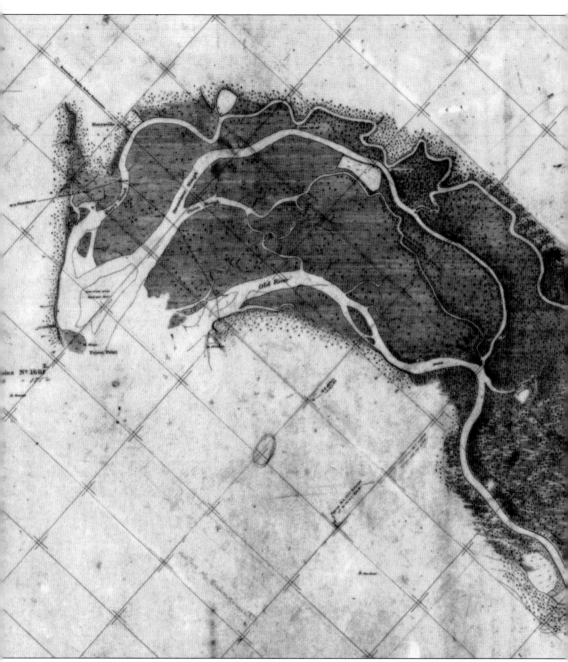

SNOHOMISH RIVER CHART, 1854–1855. The authors of volume one of *River Reflections* list the names of 69 steamships that answered the call to move both passengers and freight in Snohomish County; most important, they carried the mail. The idiosyncrasies of the ships, the personalities of their captains, and the moods of the river were reported on extensively in the newspapers. Ferguson

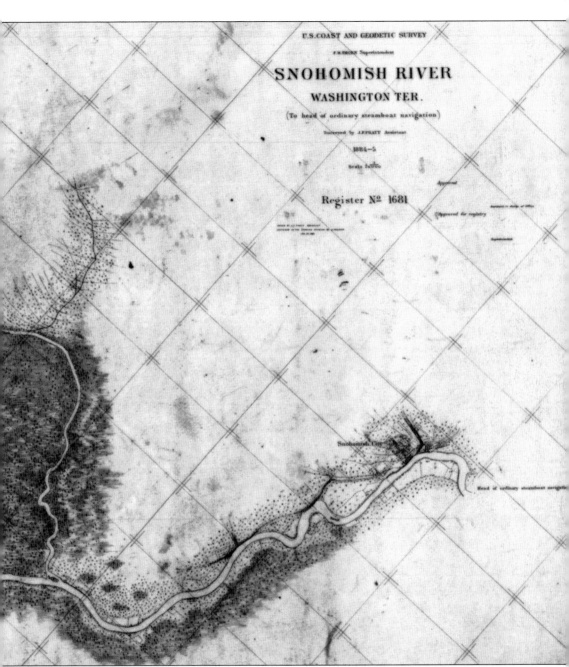

reminisced in an interview later in life about his first trip upriver in 1860: "The Snohomish River was at the time a very weird place, the trees along the banks with their long branches extending out over the river, in many places meeting, with long strings of moss hanging from the branches, which nearly shut out the sunlight." (UW, Map 111506.)

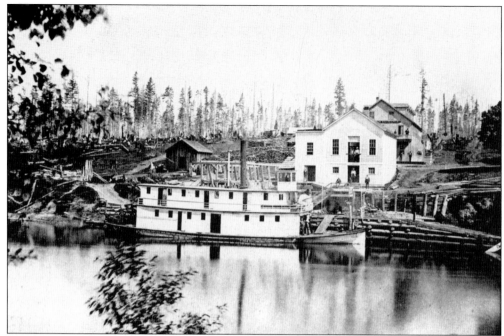

STERN-WHEELER NELLIE, 1877. The *Nellie* was only a year old when this picture was taken of her tied up at Ferguson's Wharf, downriver from Jackson's. This stern-wheeler met the demands of upriver farmers, like F. M. Duvall, for reliable transport of their crops to market, since it was designed for low-water navigation. Farmers considered native-operated canoes for hauling goods overpriced and undependable. (BO-008.)

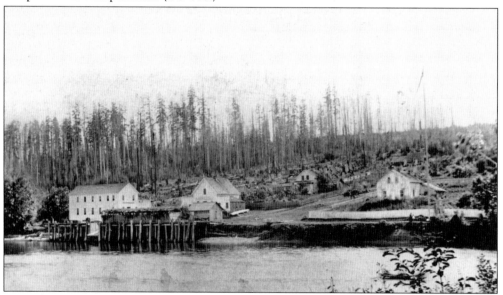

LOWELL ON THE SNOHOMISH RIVER, C. 1885. It seems a favorite entertainment was taking moonlight excursions 6 miles downriver to Lowell for dancing on the wharf. A report in the *Snohomish Eye* told of one such trip with 90 passengers on board that became stuck on a snag returning home. The partygoers had to wait to be rescued by the incoming tide the next day. (Horton, UW 12433.)

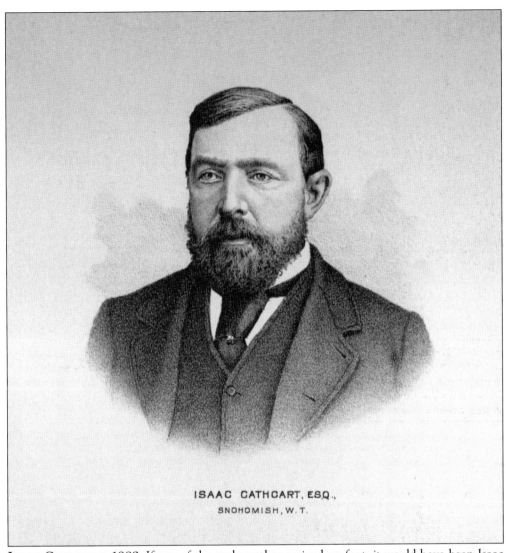

ISAAC CATHCART, ESQ.,
SNOHOMISH, W. T.

ISAAC CATHCART, 1889. If any of the early settlers arrived on foot, it would have been Isaac Cathcart. Pictured here as published in *The History of the Pacific Northwest: Oregon and Washington*, the large-framed Irishman, recently from Michigan, had been working in the county since 1869, felling trees in the isolated logging camps. Within four years, he had saved enough money to build the Exchange Hotel, shown hiding behind the Ferguson warehouse in the photograph on the facing page. It was his first step toward becoming the richest man in the county. Another newcomer in 1872 who also went into the hotel business was William Romines, who purchased the Riverside Hotel from John Low. However, this was Romines's first and last step toward business success. Within two months, he sold out and bought a farm upriver, called Lone Hill, which also failed, and he became a ward of the county known as "Uncle Billy." (Northwest Room.)

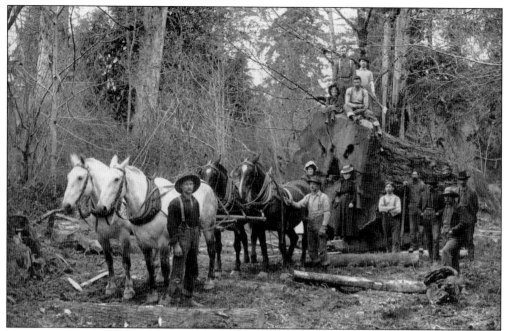

BLACKMAN BROTHERS LOGGING OPERATION NO. 1. The horses (and oxen) were treated very well; in fact, teamsters were at the high end of the pay scale, for obvious reasons. Less obvious is that animal strength was vulnerable to the forces of gravity. Until the introduction of the "steam donkey," skidding logs was a system without brakes. (LG-053.)

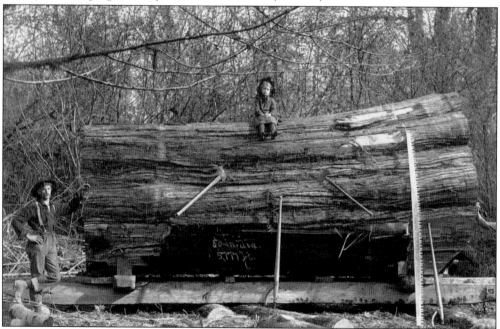

BLACKMAN BROTHERS LOGGING OPERATION NO. 2. Women and children were included in logging operations only when accompanied by a photographer. Especially impressive in this photograph is the length of the crosscut saw used to cut the giant tree into somewhat manageable sections. (LG-49a.)

Two

HARVESTING THE GIANTS

While Emory Ferguson was putting the finishing touches on his cottage overlooking the river, Edison Cady was plying the stream with his scow the *Minnehaha*, bringing supplies from Port Gamble, directly across the Sound, to logging camps up and down the river—where an unrecorded number of loggers were already felling trees on lands of questionable ownership. William Talbot began operating the Puget Mill, located in the sheltered harbor of Port Gamble, in 1853. Two years later, Talbot was shipping four million board feet of lumber to his partner Andrew J. Pope in San Francisco. (The mill remained in operation until 1995.)

During their first year on the river, Ferguson and Cady raised funds for an expedition to establish a pack trail to the eastern side of the Cascade Mountains in anticipation that the next gold and silver rush would bring a steady stream of miners through Snohomish, still called Cadyville. They followed the route established by Cady the previous summer, which still bears the name Cady Pass. With the help of a Wenatchee Indian guide, they followed rivers and rafted across lakes, finally reaching the Kettle River—nearly 400 miles away—before turning around and heading home empty-handed. The existing mines were not producing enough to use their trail.

Back home, Ferguson concentrated on politics and business, first with the establishment of Snohomish County, then by building a one-story structure near his cottage that was licensed for operation as the Blue Eagle Saloon on November 14, 1864. Cady went back to working the river until the Sinclairs bought him out. He exits this story and has disappeared from the pages of Pacific Northwest history, but he is remembered around town with a park and boat launch bearing his name.

Three brothers arrived in the area, having sold their lumber business in Maine. Perhaps it was from their first sight of the Pacific Northwest forests, thick with giant cedar and fir trees gently swaying in the wind, that Alanson, Elhanan, and Hyrcanus Blackman were inspired to revolutionize the logging industry.

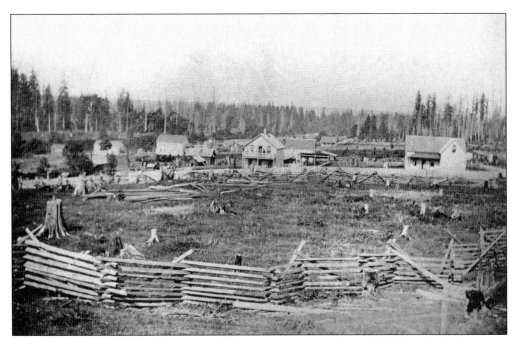

AVENUE B, 1874. This rare view of early Snohomish may have been how the town looked to the Blackmans on their first visit. The river is barely visible on the left and none of the buildings are recognizable today. Note the thickness of the surrounding forest, which matches the number of stumps in the pasture making up the foreground. (UW 21899.)

AVENUE B NO. 1, C. 1885. The name of Avenue B should be changed to "Blackman Avenue" since all three brothers built homes on this street, most likely included in this photograph by the resident pioneer photographer Gilbert Horton. (Horton, SG-024.)

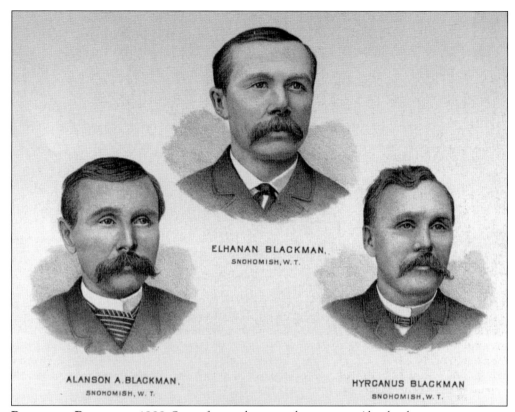

ELHANAN BLACKMAN,
SNOHOMISH, W. T.

ALANSON A. BLACKMAN,
SNOHOMISH, W. T.

HYRCANUS BLACKMAN
SNOHOMISH, W. T.

BLACKMAN BROTHERS, 1889. Sons of a woodsman with seven years' lumber business experience back in Maine, they found work immediately in Lowell; but within two years, Alanson and Elhanan opened their first logging camp near Snohomish. Hyrcanus was the youngest brother, who minded the books and politics. (Northwest Room.)

AVENUE B NO. 2. The extraordinary growth of early Snohomish is due to the logging industry, and the Blackman brothers were the guiding lights of that industry in this neck of the woods. (SG-023.)

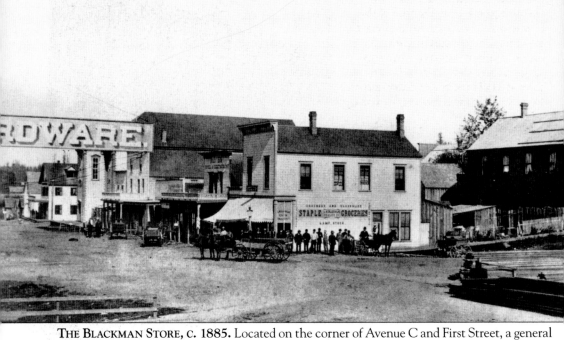

THE BLACKMAN STORE, C. 1885. Located on the corner of Avenue C and First Street, a general store occupied the first floor. A jeweler, a confectioner, and the new lawyer in town, Sam Piles, rented offices on the second floor in 1885. Piles and others went up against Ferguson, urging the drastic action of asking the few Chinese living in Snohomish to leave. This was the year of the anti-Chinese movement throughout the Pacific Northwest, and the serious rioting in Seattle was noted in Snohomish. Piles and the others prevailed, and some 18 Chinese residents quietly left on the next steamship out of town. Three others wanted to sell their laundry business first and promised to leave on the Tuesday boat, but the excitement of the times got the best of a misguided gang, who placed explosives under their shop on Avenue B, blowing it to bits. Fortunately there were no deaths, and unfortunately there were no convictions. Piles went on to serve in the U.S. Senate from 1905 to 1911. (Horton, UW21898.)

**SNOHOMISH HARDWARE STORE,
c. 1890.** Visual evidence suggests
that Gilbert Horton took the
picture of the Blackman Store on
the facing page from the roof of the
Snohomish Hardware Store, since it
explains the sign sneaking into the
image. Sanborn maps confirm this
suggestion by showing a hardware
store at 1119 First Street, kitty-corner
from the Blackman Store. (BU-031.)

**SNOHOMISH HARDWARE STORE
INTERIOR, c. 1890.** Only the men
are identified in this picture: from
left to right, Gene Hyman (owner),
G. M. Cochran, Frank Buckley, and
Mert Hewitt. Cochran took over the
business in 1898, and it remained a
family business until they "ran out of
Cochrans," reported the *Tribune* upon
the store's closing in 1967. (BU-032.)

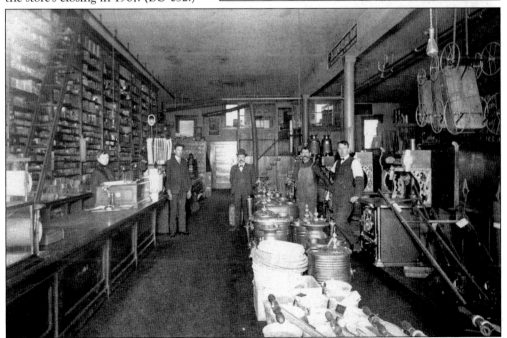

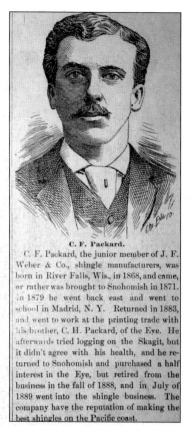

C. F. Packard.

C. F. Packard, the junior member of J. F. Weber & Co., shingle manufacturers, was born in River Falls, Wis., in 1868, and came, or rather was brought to Snohomish in 1871. In 1879 he went back east and went to school in Madrid, N. Y. Returned in 1883, and went to work at the printing trade with his brother, C. H. Packard, of the Eye. He afterwards tried logging on the Skagit, but it didn't agree with his health, and he returned to Snohomish and purchased a half interest in the Eye, but retired from the business in the fall of 1888, and in July of 1889 went into the shingle business. The company have the reputation of making the best shingles on the Pacific coast.

THE *SNOHOMISH EYE*, JULY 11, 1883. Clayton H. Packard was the publisher and editor of the second newspaper in the county, the *Snohomish Eye*, beginning January 1882. Alanson Blackman's invention of the logging car or truck was front-page news in the July 11, 1883, issue, even warranting a rare line engraving.

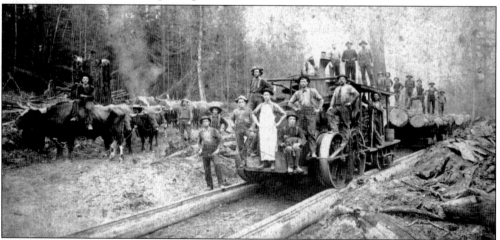

BLACKMAN BROTHERS RAILWAY, C. 1885. A rare image shows the Blackman logging engine pulling several loaded log trucks on wooden tracks. Unlike tracks made of iron, wood tracks did not require an elaborate roadbed since wood could follow the contour of the land, making installation much easier and quicker. (Peiser, RR-001.)

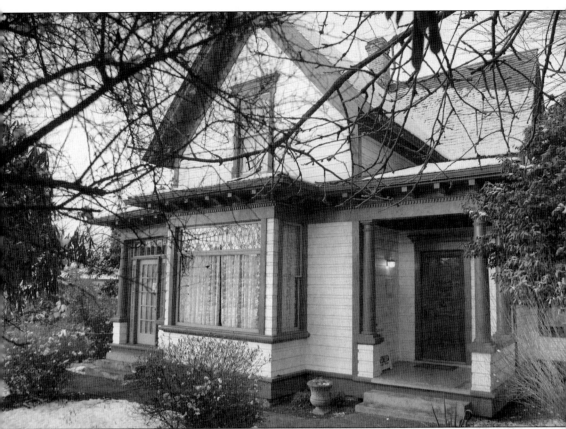

BLACKMAN HOUSE MUSEUM, 2006. Hyrcanus and his wife, Ella, built this cozy house in 1878. Their son Clifford was born here in 1884; he led an active but short life, dying from the flu in 1909, the same year daughter Eunice married Dr. William S. Ford. Hyrcanus died in this house in 1921, only 74 years old. Ella passed away six years later. While visiting her daughter's family in California, Eunice became ill and eventually decided to stay. In Snohomish, Bill Bates, editor of the *Snohomish County Tribune*, discovered that the house had been broken into and vandalized. The Blackman family agreed to sell the home and its contents for mortgage payments of only $50 a month in exchange for assurance it would become a museum. After much work, and one huge estate sale, the Snohomish Historical Society held a Christmas Tea in 1970. Eunice died four years later, by which time the annual Christmas Tea was established and a renaissance of historic awareness in Snohomish was in progress. (Blake.)

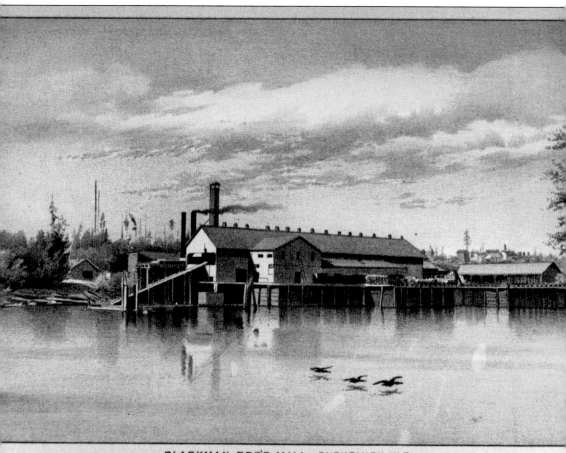

BLACKMAN BRO'S MILL, SNOHOMISH, W.T.

BLACKMAN MILL, 1889. This fine art lithograph was published in the two-volume *History of the Pacific Northwest: Oregon and Washington*. Elhanan Blackman invented the tripper shingle machine, in which a carriage holding a block of cedar is tripped by a ratchet action, moving the block in and out from the saw, creating a shingle with each pass. After only two years, this mill was producing 10 million shingles a year. The mill also boasted the first drying kiln, indicated by the thicker smokestack built of brick. Kilns are still used to reduce the weight of lumber. A dried bundle of shingles weighs 60 pounds less than a bundle of green ones; and, considering that the market for Snohomish shingles was the East Coast, less weight meant a considerable savings in shipping costs. This mill is considered the first in Snohomish to produce finished shingles and lumber that exceeded local demand, which means that the Blackmans anticipated the arrival of the railroad and were ready with product for export. (Northwest Room.)

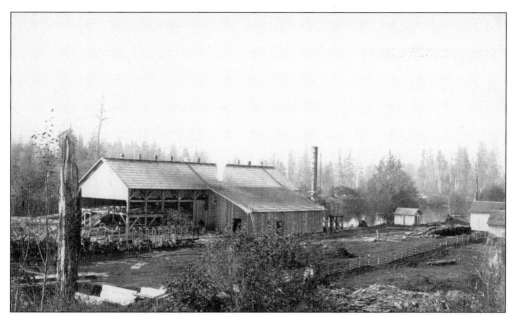

BLACKMAN MILL, C. 1885. The first sawed shingle in the county came from this mill, located west of Avenue D. In 1887, the mill burned to the ground in a fire of suspicious origin. A crowd gathered nearby for a political speech formed a heroic bucket brigade that succeeded in preventing the fire from spreading into town. (Horton, Snohomish County Museum.)

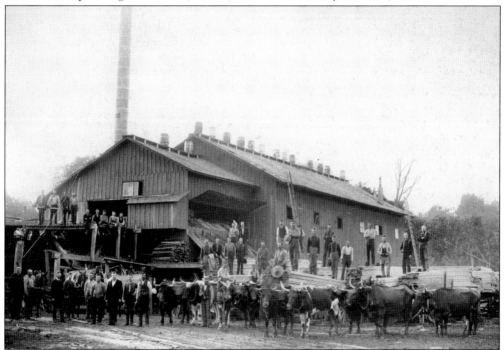

BLACKMANS' GRANITE FALLS MILL, 1892. Undaunted by the loss of their first mill, the brothers built a larger mill farther downriver, but it burned before becoming operational. Pictured here is likely the Blackmans' third mill. Historic accounts refer to the Blackman brothers' logging operations as the "industrial backbone" and the "economic engine" of Snohomish. (LG-127.)

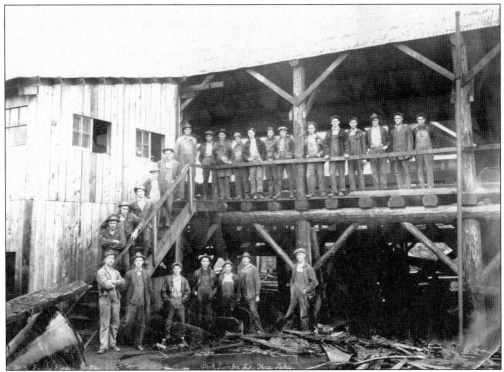

BUCK LUMBER COMPANY, C. 1900. The Buck brothers established this mill on the Pilchuck River. They also had a logging operation farther up the river that employed 20 men during the season. In 1901, they floated two million feet of cedar logs and three million feet of fir logs downriver to this mill. (D. Kinsey, LG-033.)

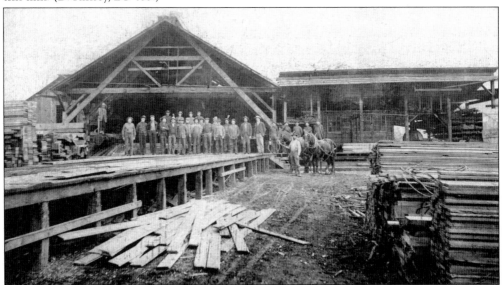

MORGAN BROTHERS LUMBER AND SHINGLE MILL, C. 1900. The Morgan Brothers Mill was located on the Pilchuck River some 800 feet south of the Bucks' operation. Known as the Bennett and Witter Mill when it opened in 1876, it was the first mill in Snohomish, and the first board milled was used in the Atheneum Building (see page 45). (LG-103.)

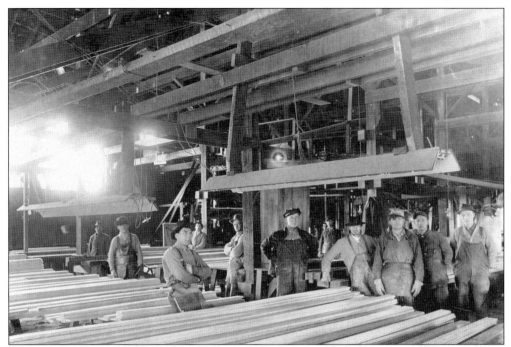

CASCADE PLANING MILL, 1914. It wasn't all shingles in early Snohomish. By the early 20th century, promotional literature boasted of three sash-and-door manufacturing factories and one operation turning out broom handles. (LG-093.)

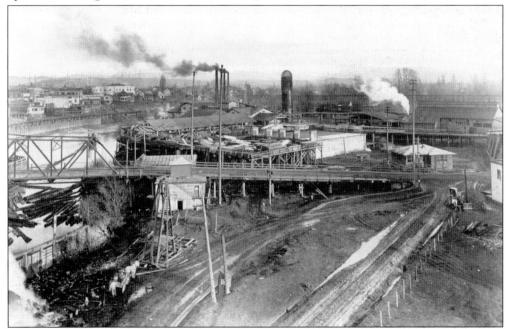

CASCADE SHINGLE AND LUMBER MILL, 1914. This view is from the west, looking toward town and showing the complete layout of the Cascade operation, located on the Harvey claim. The large white structure near the horizon is the Eagles Hall, and just in front of it sits the Ferguson Cottage. (LG-094.)

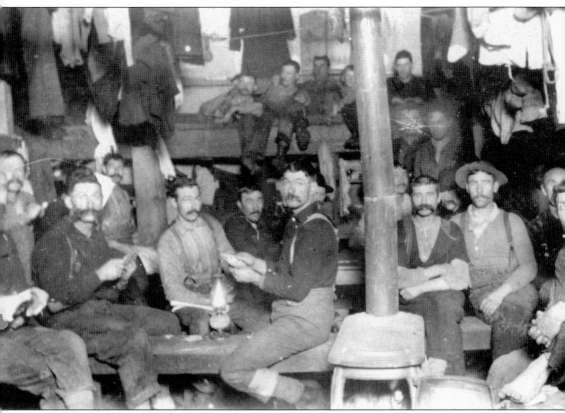

Loggers in Bunkhouse Interior, 1892. The caption on the image (not shown) reads: "155A. Flashlight view showing 1892 loggers enjoying an evening in the bunkhouse." Darius and Tabitha Kinsey worked as a team beginning in 1869, the year that they were married in Whatcom County, Washington. He took the photographs, principally in the Northwest, and she developed the prints in their Sedro Woolley home and studio—a partnership that continued for 50 years. Prints of the logging camps like the one above were sold to loggers for 50¢ to $1.50 each. Darius fell from a stump in 1940, ending his career as photographer, and he died five years later. Tabitha sold the collection to a Seattle collector who cared for the 4,700 negatives and 600 prints for 25 years, when California photographers Bohn and Petschek purchased them. After carefully documenting and researching the lives of the Kinseys, they published a two-volume book in 1975 that includes essays by the Kinsey children, Dorothea and Darius Jr. Tabitha died in 1963. (Kinsey, UW D. Kinsey 155A.)

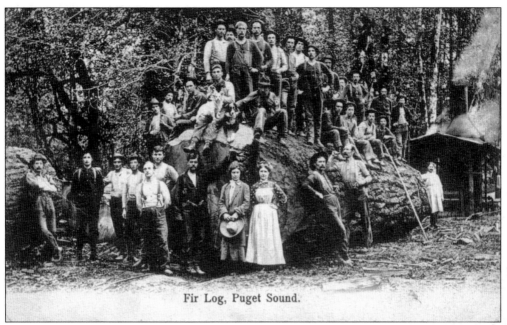

Fir Log, Puget Sound.

POSTCARD. This postcard is a perfect example of how the photographer brought the whole family with him to document the conquest of a giant. A moderately large crew would consist of a foreman, a teamster, two fallers, two sawyers, two swampers, two barkers, a hand skidder, a hook tender, a skid greaser, a land man, and of course a cook, most likely a woman.

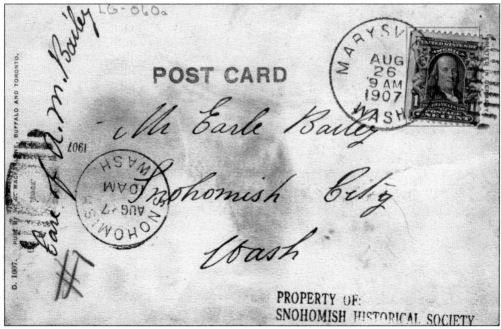

REVERSE, POSTMARKED 1907. It took a week to set up camp in the woods, and then the entire crew would help prepare an initial "landing" and "skid roads" into the timber. A spasmodic quivering in the topmost twigs as steel wedges are hammered into the cut is the sign fallers look for to call out a warning and jump clear of the falling giant. (LG-060.)

THE SHILLALAH, 1874. This first issue is probably in the hand of its editor, Eldridge Morse, who describes his effort as "A Live News Paper, devoted to Art, Science, Literature, and General News, regularly issued now and then, designed to promote harmony, sociability, good nature, and good behaviour." Over the next year, the *Shillalah* and its successor, the *Athenea*, appeared twice monthly to be read aloud at meetings of the Atheneum and circulated among the members. Morse's handwritten efforts led to his purchase of a used printing press in Olympia, and after shipping it north to Snohomish, he taught himself typesetting. In partnership with Dr. Albert Folsom, he published the *Northern Star*, the first true newspaper in the county, in 1876. (UW, *Athenea*, Acc. 4601.)

Three

THE CULTURE OF FRONTIER ISOLATION

Trying to imagine the thinking of pioneer ancestors is unavoidable as one assembles the record of their deeds, but imagination gives way to the frustration of facing a locked door without firsthand accounts. This is why diaries are such a useful key to understanding the amazing accomplishments of those first days.

With the approach of winter 1873, the Snohomish (self-called) elite established a center of learning, naming it the Atheneum, which led to the writing of a unique community journal of thoughts and happenings of frontier life. The *Shillalah* was its handwritten newsletter, produced twice a month for a little over a year. The neatly written pages, stitched together with thread, open many doors revealing a curious and complex variety of antidotes to the cultural insularity of pioneer existence. The first issues read as a self-conscious rejection of that isolation. Later, when the women take over writing the journal, changing the name to the *Athenea*, the mix of contributions expands to include articles from interested readers, copied news stories, and poems, along with local news.

An article entitled "Women's Rights" spells out the concerns of Snohomish's educated women. The writer takes on the conventional domestic arrangement of the husband controlling all the money: " . . . her right to have the money they have and not to be obliged to go to him to ask for every dollar she wants and then have him ask her what she wants to do with it then after she has explained very minutely every article she wishes to purchase, have him say, 'Oh, you will have to do without such flummery—can't afford it now.' I protest such tyranny as that."

It seems that women didn't travel 2,000 miles or more, and live without amenities, just to continue the domestic patterns they despised. And while most women married soon after arriving in Snohomish, marriage did not mean they accepted subjugation. Their writings make it clear that the uncorseted women of early Snohomish contributed to all aspects of community activities.

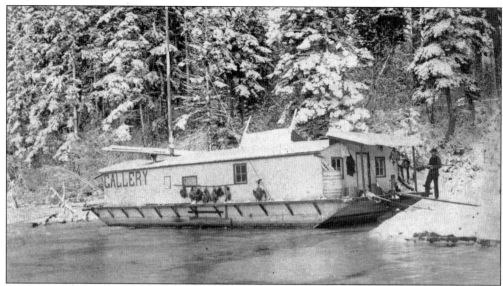

THE PALACE FLOATING GALLERY AT SAMISH ISLAND, C. 1885. This photograph studio on a barge first shows up in the news around 1880 as owned by David R. Judkins, who sold it in 1884. It was apparently purchased and operated by Gilbert D. Horton and somebody named Lewis from 1884 until 1886, when the partnership dissolved. (Horton, BO-002.)

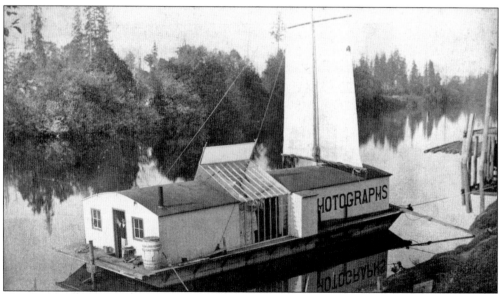

THE PALACE FLOATING GALLERY AT SNOHOMISH, C. 1885. Horton operated it alone until 1888, when the *Snohomish Eye* reported in its first issue, "Horton has sold his floating gallery to a Seattle gentleman who will take it to Stanwood next week." Horton opened a stationery store in Snohomish and remained in this profession until his death in 1936. (Horton, Snohomish County Museum.)

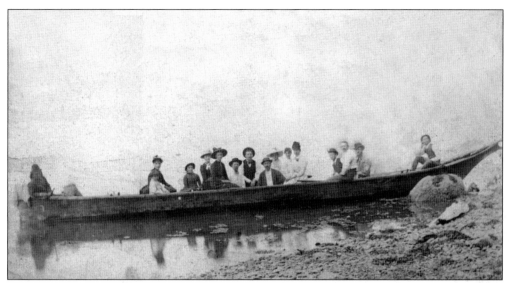

SNOHOMISH ELITE OUTING NO. 1, C. 1885. Looking closely, it appears that the same group is the subject of both photographs on this page—an outing with the elite of Snohomish. Native-operated riverboats were vital to the growth of early Snohomish, yet they were the topic of much ridicule and derision in Morse's newspaper the *Northern Star*. (Horton, RC-047.)

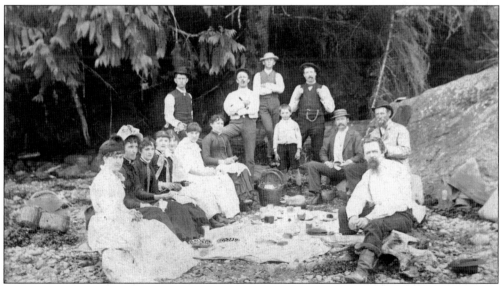

SNOHOMISH ELITE OUTING NO. 2. On the left is the photographer's wife, Margaret Horton; next to her is Jennie Wilbur. Her husband, Lot Wilbur, is the first male on the right; and behind him is Eldridge Morse, the editor of the *Shillalah*, where he used the term "Snohomish elite" to describe the leaders of the community. (Horton, RC-046.)

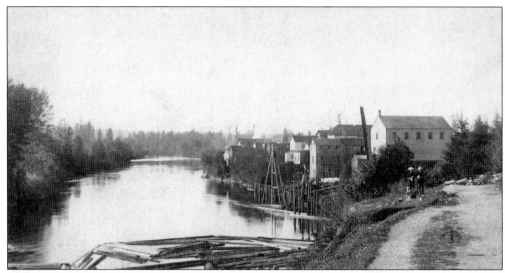

VIEW DOWNRIVER, C. 1885. This view is looking west and the road may be Commercial Street. None of the buildings pictured have survived. Most were built quickly and cheaply as warehouses to handle shipments arriving and departing by steamship. (Horton, FS-028.)

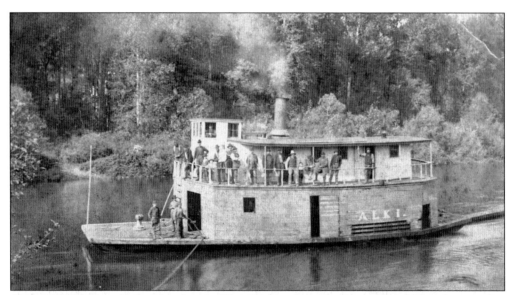

ALKI, C. 1885. Named after the place in West Seattle where the first settlers of Seattle arrived—including Snohomish's own Mary Low Sinclair and John Harvey, who landed there several months later—the *Alki* was the first steamship designed for use only on the rivers. It was the first steamship to reach Fall City, 40 miles upstream, in July 1883. (Horton, BO-001.)

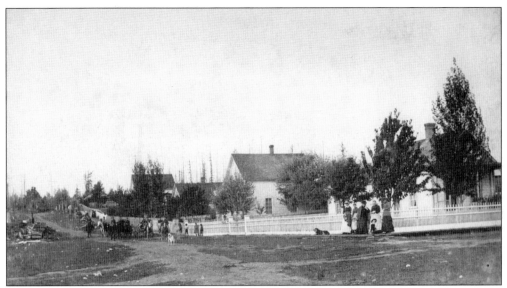

AVENUE D, C. 1885. The names of the group on the corner were recorded on the reverse of this image. They are, from left to right, Maggie Black, Zellah Lawry, her son Charles, Sarah Elwell, Olive Getchell, Ella Blackman, her two-year-old son Clifford, and an unnamed dog. (Horton, Snohomish County Museum.)

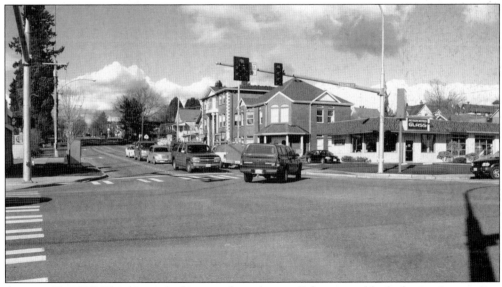

AVENUE D, 2007. This view is looking north up Avenue D from arguably the busiest intersection in modern Snohomish, very popular during political campaigns, with candidates' supporters waving signs on all four corners. A person on foot probably means that their car broke down. (Blake.)

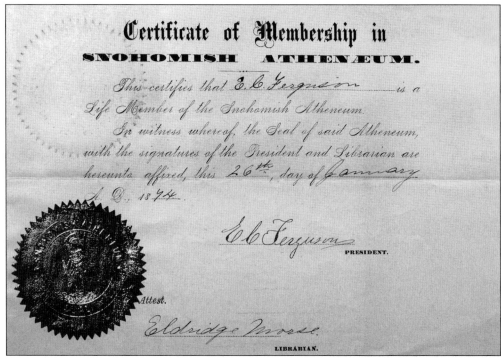

Certificate of Membership in
SNOHOMISH ATHENÆUM.

This certifies that E. C. Ferguson is a Life Member of the Snohomish Atheneum. In witness whereof, the Seal of said Atheneum, with the signatures of the President and Librarian are hereunto affixed, this 26th day of January A. D., 1874.

E C Ferguson
PRESIDENT.

Attest.

Eldridge Morse
LIBRARIAN.

CERTIFICATE OF ATHENEUM MEMBERSHIP, 1874. Articles of Incorporation of the Snohomish Atheneum were adopted November 24, 1873. A life membership was granted for $25—around $400 in 2006 dollars. Emory Ferguson served as its first president; Eldridge Morse was the librarian; and Dr. Albert Folsom was the corresponding secretary. (UW, Ferguson, E. C. Acc. 4726-001.)

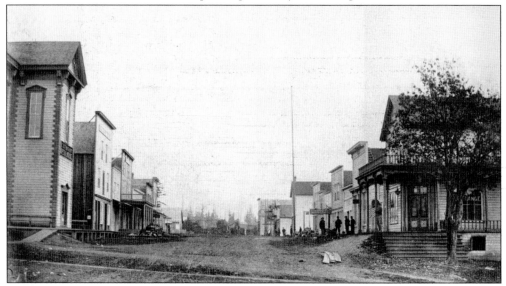

FIRST STREET AT AVENUE D, C. 1885. The building on the left is the Atheneum, embarrassingly sold to Isaac Cathcart in 1877 when the literary society ran out of funds, and its name changed to the Cathcart Opera House. The hotel across the street also changed names with each new owner; in 1888, it was labeled as the Plasketts Hotel on the insurance maps. (Horton, Snohomish County Museum.)

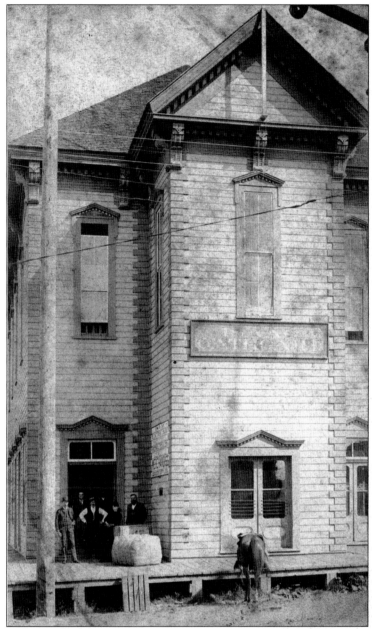

THE SNOHOMISH ATHENEUM, C. 1876. The society's inspirational leader was Dr. Albert C. Folsom, scientific, literate, and a former army surgeon with experience in the Civil War. In his 40s, he settled in Snohomish around 1869 with a broken heart from a failed marriage, but also with over 100 fossils, gems, and bones. He and Eldridge Morse led the way toward the building of a museum to exhibit his collection and provide a place for meetings. Moreover, the elite of frontier Snohomish pooled their private collection of books to form a lending library of some 300 volumes, including Darwin's *Descent of Man* (1871). The women of the membership formed their own club and raised funds to purchase a piano for the building. It was the first piano of Snohomish, and it is still available for use in the library. Isaac Cathcart opened a store and upscale saloon on the ground floor—that appears to be him standing on the right. (SG-029.)

JENNIE AND LOT WILBUR. Shown here as an older man, Lot Wilbur, accompanied by his wife, Jennie, arrived in Snohomish at age 29 from Michigan, by way of Olympia, to sell insurance. One of his first sales was to William Whitfield, the contemporaneous historian. In turn, it seems that the Wilburs were sold on settling in Snohomish. (PE-656.)

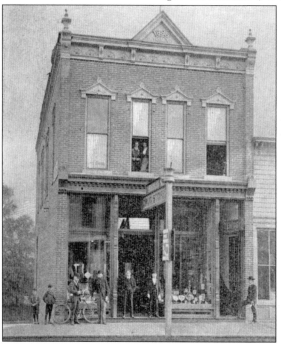

J. S. White.

J. S. White, the well known architect and builder, is a native of New Hampshire, and learned his trade in the city of Topeka. He came to Snohomish early in 1884, and has been engaged ever since in building and contracting. He is the architect and builder of nearly every building of note in the city. Among the residences built by him are those of E. C. Ferguson, O. E. Crossman, Mrs. Sinclair, H. C. Comegys, H. D. Morgan, etc., etc. Among the business blocks and fittings put up by him are Wilburs, Burns, A. M. Blackman's, Otten's store, Burton & Thorntons, Plaskett's hotel, part of the Blackman block, Methodist church and many others. Mr. White is a fine architect, and all these buildings are after his own plans. He never charges for plans, however, where he does the building. His work is faultless, and speaks for itself.

LOT WILBUR'S DRUGSTORE, C. 1891. Wilbur opened his first drugstore on December 18, 1875, and recorded $2.50 in receipts. Thirteen years later, he built this handsome brick building, designed by John S. White. It was the second brick building in the county and is still standing.

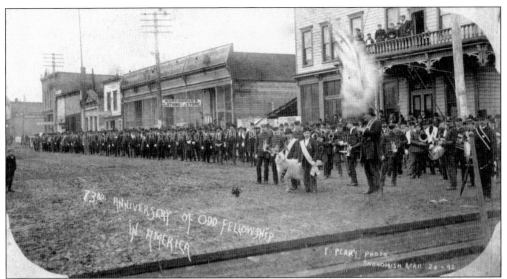

THE 73RD ANNIVERSARY OF ODD FELLOWSHIP IN AMERICA, 1892. Most men joined an organization simply to purchase insurance. The goat included in the picture above was used in initiation rites; it seems nothing bonds men together like being bucked trying to ride a goat—something insurance companies would not allow these days. (Perry, PA-002.)

MASONIC HALL, 1903. This graceful structure, located on the corner of Second Street and Avenue C, was already 24 years old in this photograph. It is considered the first lodge building in Snohomish and served as the county courthouse until 1892. The second lodge building, for the Odd Fellows, was built in 1886 across the street and is still standing today. (Northwest Room.)

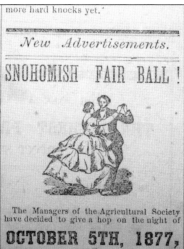

THE religious war, now raging in the east, is the age, civilization and humanity.

Mr. H. A. Gregory's little son, whose injury was reported last week, is doing well.

FERGUSON & Morgan's mill running night and day. They are putting in a substantial dam.

YOUNG lovers have been charmed by dog-oned moonlight concerts the past week.

GEO. Hansel of Port Townsend and Mr. Brooks of Seattle were in town last week.

JAS. Hood and Ed. Elwell have the contract of taking the logs from Roberts' and delivering them at the point. Success to the new firm of Hood & Elwell.

Mr. Romines has sold his new wharf property in town and purchased a farm on the Snohomish at the mouth of the Skykomish.

more hard knocks yet.

New Advertisements.

SNOHOMISH FAIR BALL !

The Managers of the Agricultural Society have decided to give a hop on the night of

OCTOBER 5TH, 1877,

AT.

ATHENEUM HALL,

Good music will be provided. Supper by Mr. I. Cathcart of the Exchange. Tickets including supper $2 50 n85 5w.

NOTICE.

NORTHERN STAR CLIPPING, 1877. This advertisement from the first newspaper of the county is promoting a dance to benefit the Agricultural Society. The small print explains that Isaac Cathcart provides the supper from his restaurant at the Exchange Hotel, right across the street from the Atheneum Hall. To the left is a notice that Romines has sold his property in town and purchased a farm upriver.

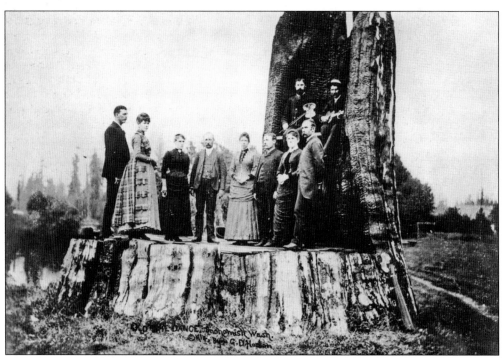

DANCING ON A CEDAR STUMP, C. 1885. Of course, Horton's camera couldn't capture the group actually dancing, although it could have produced a fascinating blur of frontier fun. Pictured from left to right are William and Delia Deering, Oscar and Bertha Crossman, George and Laura England, Ruth Elwell, and Omar Moore; above, on the fiddle is W. P. Bell, and the photographer's brother Harvey is on the banjo. (Horton, BT-024.)

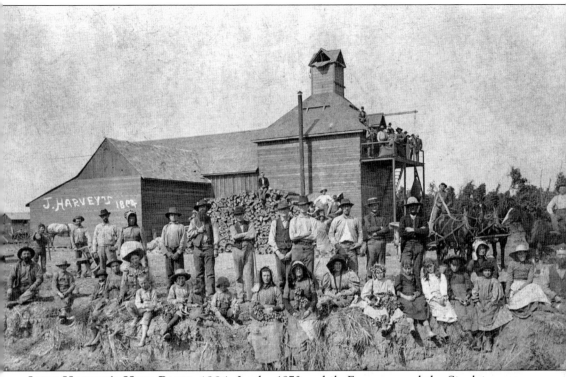

JOHN HARVEY'S HOPS BARN, 1884. In the 1870s, while Ferguson and the Sinclairs were planning a town site, Harvey was establishing a farm on the south side of the Snohomish River. It was an English boyhood notion of his that all of America was fertile farmland; and here he was, 30 years old and the proud owner of 160 acres of the richest river valley bottomland that he could ever imagine. Family records tell of Harvey selling potatoes in Port Gamble early on, but nothing about growing and drying hops. The platform near the roof was used to load the drying kiln with the harvested hops. Visible below is the stack of firewood and tall smokestack. By the size of the barn and crew, it can be assumed that Harvey was growing the hops as a cash crop. Upriver, the Snoqualmie Valley was well known for its hops farms, and the harvest was brought to market through Snohomish. Steamship passengers would often share the ride with a load of hops or other crops. (Courtesy Mike Barnhart.)

LUCETTA FERGUSON. Lucetta Morgan met Emory Ferguson in Olympia while he was serving as a member of the legislature, and they married in 1868. At this time, Emory sold the Blue Eagle Saloon to his brother Clark and built a wharf west of Avenue D. The record is unclear if the wharf included a residence or if Lucetta moved into the cottage overlooking the river. (PE-102.)

DIPLOMA, 1875. This diploma was awarded to Lucetta Ferguson for her "Baby Shirt and Baby Dress." At the time, her second daughter Ivy was a newborn. This was the first agricultural fair promoted by Eldridge Morse, editor of the *Northern Star*, and the beginning of the annual county fair tradition. (UW, Ferguson, E. C. Acc. 4726-001.)

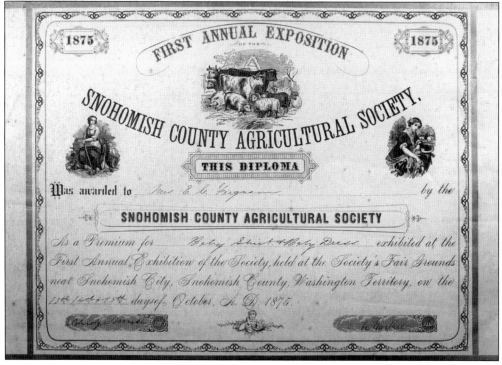

FERGUSON FAMILY, 1880. From left to right, the children are Ivy, the middle child, born in 1875; Sylvia, the oldest, born in 1869; and Cecil, the youngest, born in 1881. The family is pictured about the time they moved into the mansion shown on page 68. Descendants of the family still live in Snohomish but not in the mansion, which was lost to fire. (Northwest Room.)

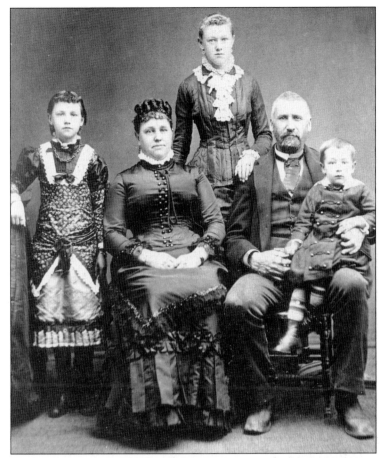

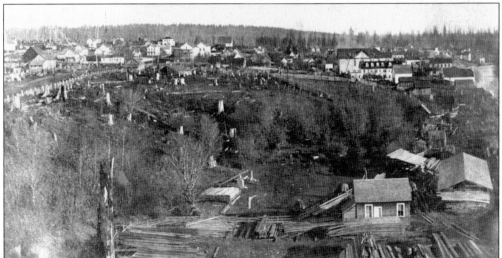

LOOKING EAST, 1886. The bottom half of this composition shows undeveloped land west of Avenue D. That is Second Street coming in from the left and a glimpse of the river on the right. Moving to the center of the image from the river, the Atheneum/Cathcart Building can be made out; it is the large structure partially hidden by the Exchange Hotel. (SG-026.)

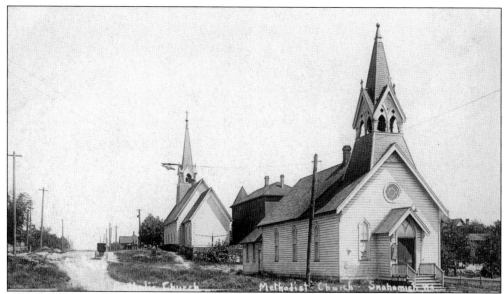

St. Michael's Catholic and First Methodist Churches. On these facing pages, three views are offered of the same subject through both time and space. The earliest image above shows both churches and Third Street, which was labeled on the insurance maps as "unpassable for teams"—meaning for fire hose wagons. (Picket, CH-005.)

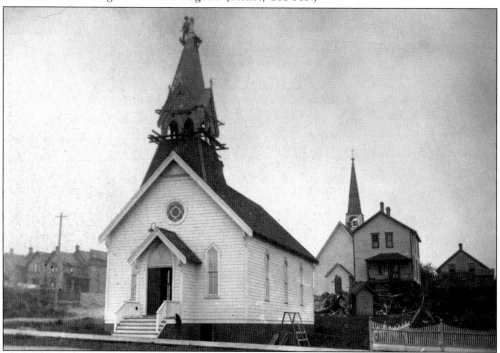

First Methodist Church Renovation. The steeple workers appear to be engaged in renovation since the body of the church looks freshly painted; also a small structure has been added to the back of the Catholic church. The Melodist church was built in 1885, designed by John S. White. The Catholic church was built several years later, using wood salvaged from a skating rink demolition. (CH-006.)

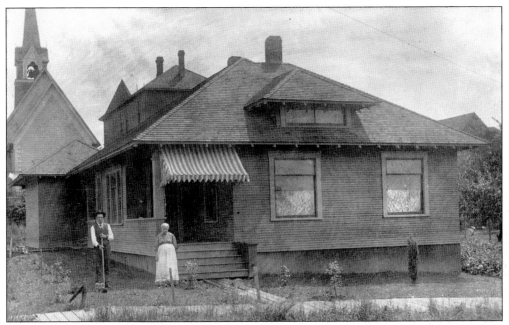

TOMPKINS HOME, C. 1910. John and Mary Tompkins are pictured here in front of their home at Third and Avenue C, built on the site of the First Methodist Church, which was moved uphill one block opposite St. Michael's. This writer has yet to learn a plausible reason for moving the church, but the story on the street is that the Methodists wanted to be higher than the Catholics.

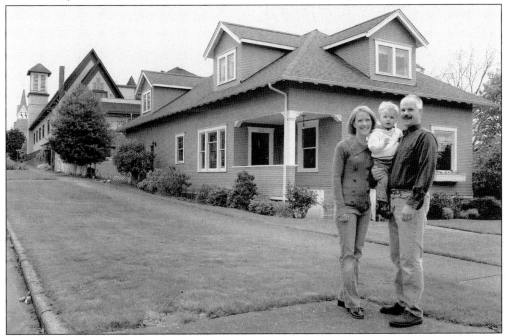

THE KRIKAWA'S HOME, 2007. Meg and Ed Krikawa (pictured above with son Sean) purchased this property in 1991. In 2004, they tore off the roof in order to add several bedrooms on the second floor, and then built a new roof—all while living on the first floor! Note the two steeples in the background. (Blake.)

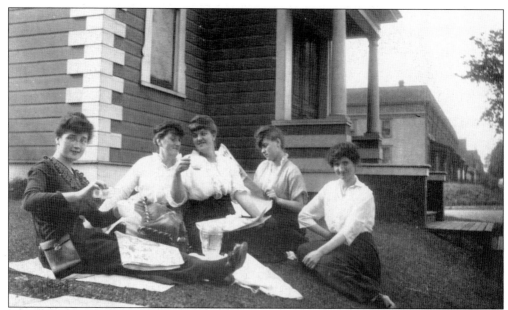

OUTSIDE ST. MICHAEL'S CATHOLIC CHURCH, C. 1915. The photograph of this joyful gathering is from an album kept by the Irish housekeepers and sisters Winifred Moran and Marguerite DeLoy. The individuals are unidentified.

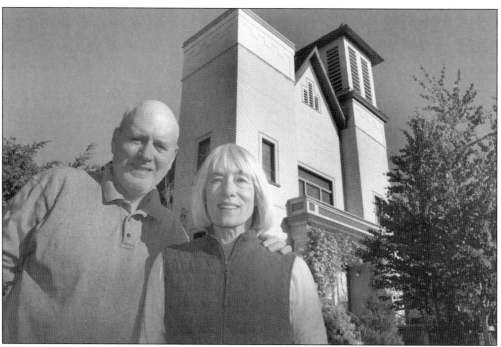

OUTSIDE THE FORMER ST. MICHAEL'S CHURCH, 2007. Karen Guzak (right) purchased the former St. Michael's property at the bankruptcy sale of its third owner, a private individual, in 1993. She and the author, Warner Blake, had just begun a new relationship, which means they spent their courtship renovating the historic structure into a home and art studio for two, plus a place for joyful gatherings. (Blake.)

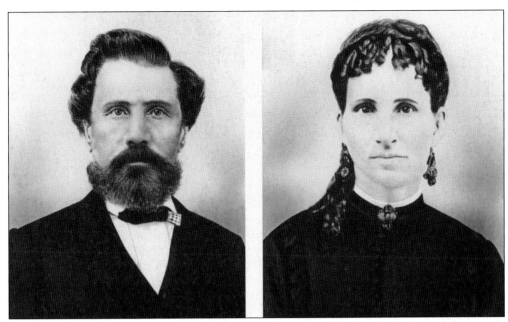

JOHN AND CHRISTINA HARVEY. Christina Noble, from New Brunswick, was visiting her sister's family in the area when she met John Harvey. The wedding party traveled by steamship to the Presbyterian church in Seattle, the closest one, for their ceremony on July 10, 1872. Christina was a midwife, and the Harvey home was the site of many births in early Snohomish.

SKETCH, FIRST PRESBYTERIAN CHURCH. Except for the Tulalip mission at Priest Point, this was the first church building in the county, begun in 1876. John and Christina Harvey (above) were among the 15 charter members, when the total population of Snohomish was around 100 men and 10 women. (Courtesy First Presbyterian, Snohomish, Washington.)

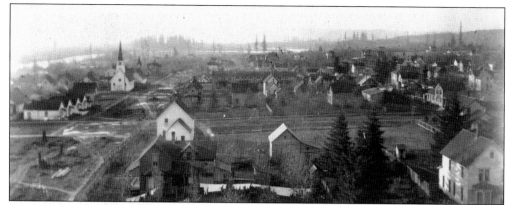

LOOKING WEST FROM THE CENTRAL SCHOOL TOWER, C. 1900. The street on the left is Third Street, which crosses Avenue A in the foreground. Avenues B and C are easily identified by the two churches back-to-back, St. Michael's Catholic Church facing this way and the First Methodist Church facing Avenue C (see page 52). Particularly striking is the view of the river meandering into the horizon. (SG-025.)

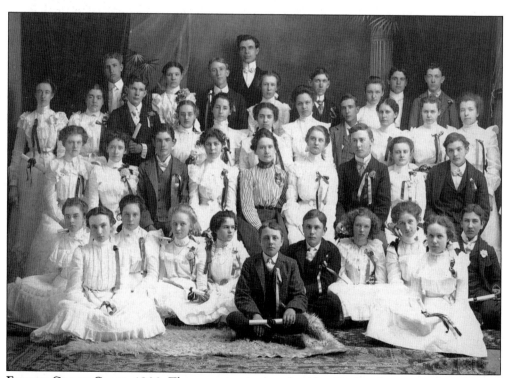

EIGHTH-GRADE CLASS, 1900. This stunning image of unidentified students attending Central School gives no hint of the turmoil churning below the surface around the issue of teachers forming a union. In 1885, a teacher dismissed for alleged incompetence sued the Snohomish school district for full pay and won in jury trial. (SC-059.)

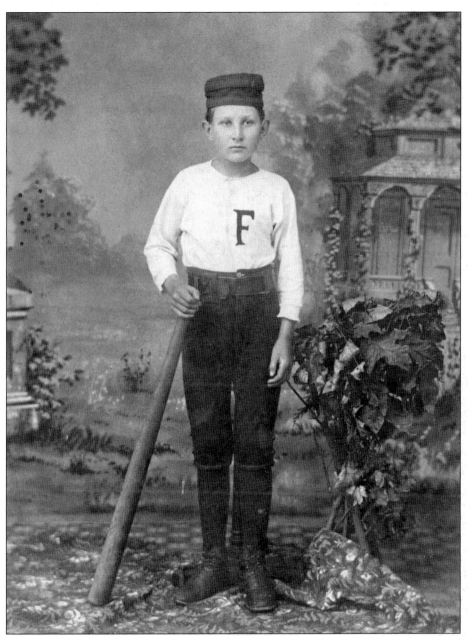

NOBLE HARVEY, C. 1885. Noble is around 12 years old in this portrait, most likely taken on Gilbert Horton's floating studio tied up at the west end of town. He is wearing the baseball uniform of the Fearnaughts. Still a teenager, he became "the man of the family" with the death of his father. He worked with the railroad people preparing the roadbed through their property and hunted game for the market (private hunting was the main source of meat for the dining establishments in town—ducks sold for $2 a dozen). His mother died on September 17, 1892, from typhoid fever. Noble, age 19, inherited the homestead consisting of about 230 acres, valued at $15,000. The following year, he attended the Chicago World's Fair, also attended by Ferguson, who was a fair commissioner and brought to the new state's exhibit a section of cedar bark 18 inches thick. This writer imagines that they traveled together. (Horton, courtesy Donna Harvey.)

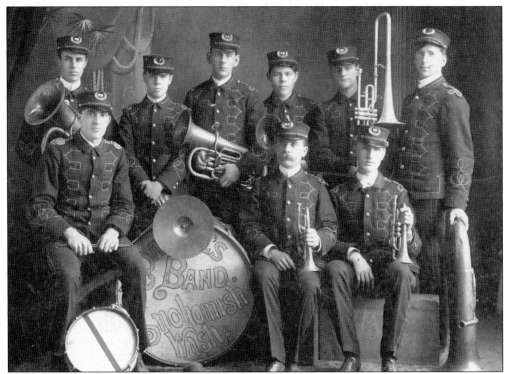

A Snohomish Brass Band, c. 1911. The May 11, 1911, issue of the *Tribune* had a six-column-wide headline announcing a Snohomish Band Carnival later that month. The article promised "six days of pleasure and many free attractions." (RC-108.)

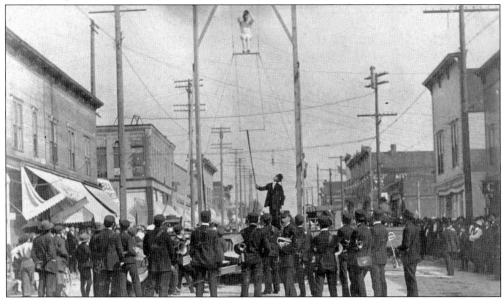

Trapeze Act, c. 1911. The newspaper story promised "three big free exhibitions every day and evening including a high wire act, a marvelous slide for life on a 300 foot wire by a man enveloped in flames balancing on a big spiral tower and many other daring acts." One of them could have been the man on the trapeze. (CE-004.)

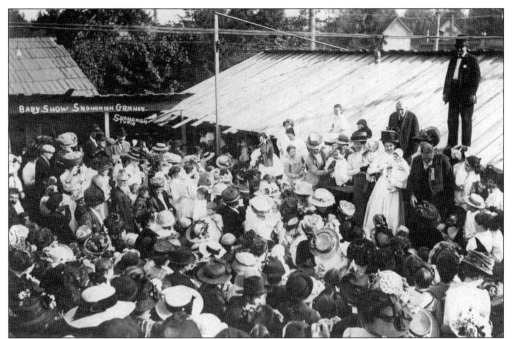

BABY SHOW, 1910. This photograph was published on the front page of the newspaper to promote an even grander "Baby Show" as part of the county fair. This contest was introduced in 1907, according to an article in the *Tribune*, where it lists that prizes for the Best Baby Boy, Girl, Twins, and Fattest Baby will be awarded. Judges were to be three bachelors. (Snohomish Studio, CE-007.)

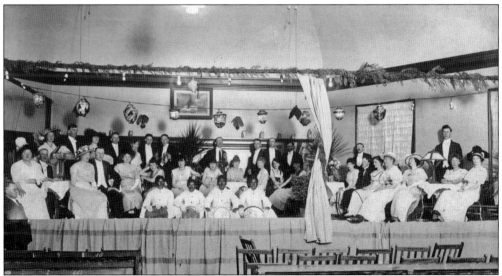

MIKADO, EAGLES HALL, 1912. "THE MIKADO A BRILLIANT SUCCESS," reads the headline in the June 14, 1912, *Tribune.* The subhead continues: "Cosmopolitan Club's Protégées Acquit Themselves Creditably, Eagles Hall Transformed Into Veritable Japanese Village." And the advertisement on the day of the performance, June 11, promised: "Catchy Songs, A Hundred Laughs; Pretty Girls in Pretty Costumes." Reserved seats cost 75¢—around $16 in 2006 money. (RD-107.)

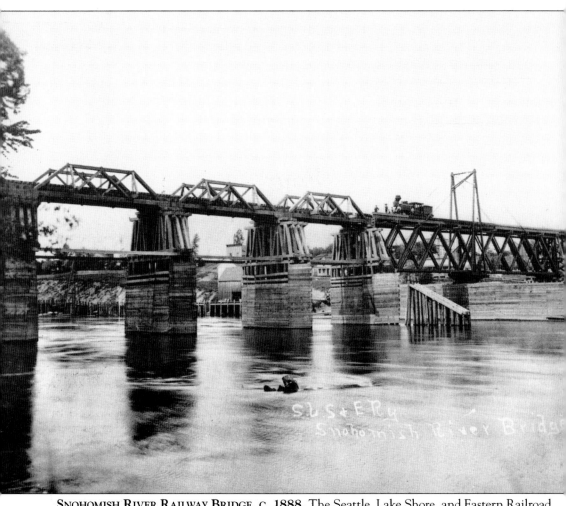

SNOHOMISH RIVER RAILWAY BRIDGE, C. 1888. The Seattle, Lake Shore, and Eastern Railroad Company lasted six years longer than this bridge. Barely months after it was completed, a span in the bridge gave way under pressure from a flood-caused logjam against the pilings. But it was quickly repaired and service resumed. However, the contentious relationship between the Northern Pacific Railroad and the City of Seattle meant it took a decade to finally reach a deal to purchase the local line. Population grew all along the line, giving birth to new towns. The downriver town of Lowell found itself with a brand-new store, a wharf, and an impressive Great Northern Hotel overlooking the bend in the river. Since it was still cheaper to ship by water than by rail, steamer traffic continued unfazed by all the fuss. (UW18022.)

Four

RAILS OVER THE RIVER

Talk of railway projects was long in the air, but it was not until 1887 that action took place on the ground. The Seattle, Lake Shore, and Eastern Railroad had surveyors working throughout the county on the plan to connect Seattle with points north, all the way to the Canadian border. On July 3, 1888, service reached the south bank of the river at Snohomish with 12 passengers, where it stopped until a bridge could be built. It seems another group of railway investors were bringing a line south from Bellingham Bay to Seattle, and they had received an injunction to prevent their competition from crossing the river. Judge Thomas Burke and Daniel H. Gilman, directors of the Seattle, Lake Shore, and Eastern, built the bridge anyway by somehow distracting the men guarding the passage across the river. Today the popular Burke-Gilman Trail, maintained by Seattle Parks and Recreation, is a fitting tribute to this pioneer spirit of taking action.

Back in Snohomish, citizens didn't mind crossing the river to take the train to Seattle, since it turned an all-day trip by steamship into less than three hours by rail. Besides, even before the arrival of the first train into downtown Snohomish, economic life was in full bloom. The Seattle *Herald* reported in 1884 that Snohomish was an old town of about 700 inhabitants, with a two-story courthouse, a new sawmill producing 20,000 feet of lumber each day, one good school building, six saloons, and one church (and that church had a bell). Products as listed by the *Herald* were "fruit, logs, hay and skating rinks"—there were two at the time.

The Seattle *Post-Intelligencer* wrote about Snohomish in 1886, "It supplies people away up on the Snoqualmie and Skykomish Rivers, up which goods are poled in canoes of from 500 to 3,000 pounds capacity. There are daily steamers, the *Nellie* and the *Cascade*, to Seattle." When the train finally pulled into the new Snohomish station on Lincoln Street, the city boasted a $1 million economy—the fourth largest on Puget Sound.

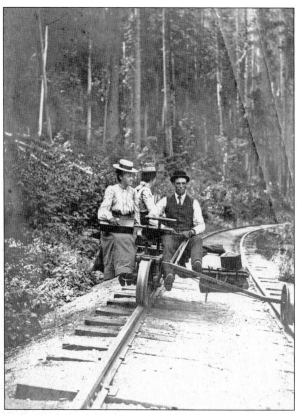

VELOCIPEDE. Sometimes called an "Irish Mail," this 150-pound, three-wheel handcar was popular with railroad employees. Unlike the 600-pound, four-wheel versions, these speeders were ideal for one- or two-person missions. As pictured here, operated by unidentified persons, they were even used by non-railway employees; in fact, the velocipede is reported to have been invented by a farmer in Michigan without suitable train service. (RR-149.)

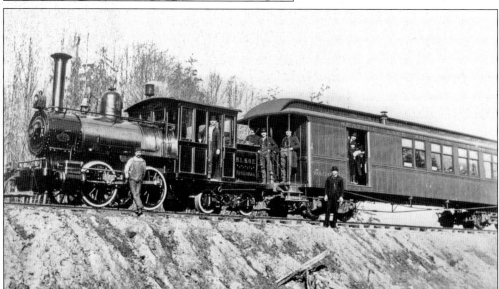

SEATTLE, LAKE SHORE, AND EASTERN RAILROAD. The little engine that could accompanied the county into statehood in 1889. County residents voted for Olympia over Ellensburg and North Yakima for the state capital, turned down Prohibition and women's suffrage, but approved the state constitution. The era of "city fathers" guiding growth was ending, as men of capital resources were about to arrive on the next train. (UW17761.)

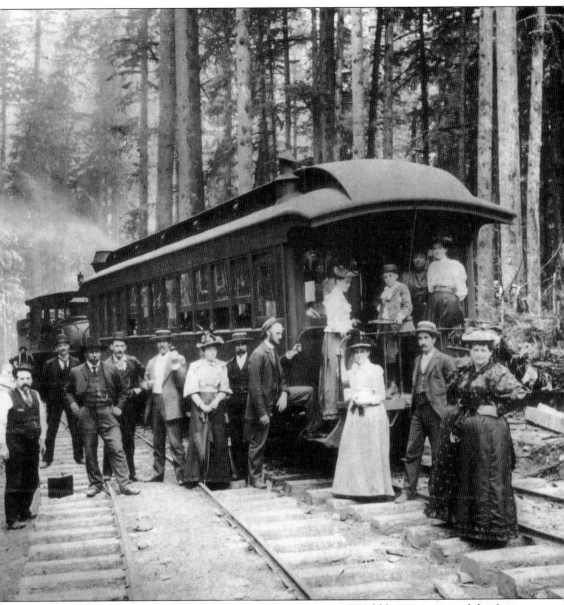

SEATTLE, LAKE SHORE, AND EASTERN RAILROAD, C. 1888. Would-be passengers of the first trains would flag them down to climb aboard. And since Asahel Curtis (1840–1931), the older brother of Edward Curtis (1868–1952), had just arrived with their parents and two sisters from Minnesota in 1888, perhaps this early train station situation was actually captured by an unknown photographer. Asahel was working for Edward in his Seattle studio when he accepted the suggestion to document the Klondike Gold Rush. Asahel stayed for two years, taking pictures and working an unproductive claim. Upon his return, Edward published the images under his own name, causing a bitter parting of the ways. Edward went on to household fame documenting and lecturing about the North American Indian, while Asahel opened his own studio in Seattle and had a successful career as a commercial photographer. It is most likely that this image was an existing print that, as in most commercial studios of the time, Asahel simply reformatted as a lantern slide and then added his name. (A. Curtis, MOHAI, 2002.3.936.)

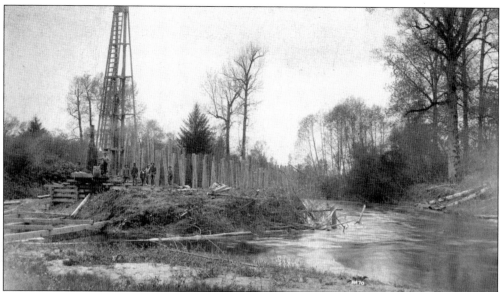

PILE DRIVING ON PILCHUCK CREEK, 1892. The Great Northern Railroad runs east-west, so it had to cross both the Pilchuck and the Snohomish Rivers on its way across the Harvey homestead. The tracks are still active, with long trains of trailer cars stretching the length of the valley floor. With help from prevailing winds, the nostalgic rhythm of the wheels still washes over the town. (LG-121.)

SNOHOMISH FROM UPRIVER, C. 1903. This unusual view of town is from the east as the river takes a left turn heading toward the Sound. The Snohomish River is formed 7 miles upriver where the Skykomish and the Snoqualmie Rivers come together. Both rivers and their tributaries drain the Cascade Mountain Range. The Great Northern Railroad uses the pass discovered by Edison Cady in 1859. (MOHAI, No. 83.10.6581.)

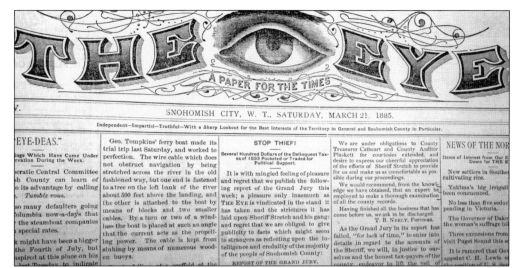

THE EYE

A PAPER FOR THE TIMES

SNOHOMISH CITY, W. T., SATURDAY, MARCH 21, 1885.

Independent—Impartial—Truthful—With a Sharp Lookout for the Best Interests of the Territory in General and Snohomish County in Particular.

EYE-DEAS."

...ings Which Have Come Under ...rvation During the Week.

...cratic Central Committee ...h County can learn of ...o its advantage by calling ... *Tumblz vous.*

...so many defaulters going ...olumbia now-a-days that ...r the steamboat companies ...a special rates.

...k might have been a bigger ...the Fourth of July, but ...spired at this place on his ...last Tuesday to indicate

Geo. Tompkins' ferry boat made its trial trip last Saturday, and worked to perfection. The wire cable which does not obstruct navigation by being stretched across the river in the old fashioned way, but one end is fastened to a tree on the left bank of the river about 500 feet above the landing, and the other is attached to the boat by means of blocks and two smaller cables. By a turn or two of a windlass the boat is placed at such an angle that the current acts as the propelling power. The cable is kept from sinking by means of numerous wooden buoys.

STOP THIEF!

Several Hundred Dollars of the Delinquent Taxes of 1883 Pocketed or Traded for Political Support.

It is with mingled feeling of pleasure and regret that we publish the following report of the Grand Jury this week; a pleasure only inasmuch as THE EYE is vindicated in the stand it has taken and the strictures it has laid upon Sheriff Stretch and his gang: and regret that we are obliged to give publicity to facts which might seem to strangers as reflecting upon the intelligence and credulity of the majority of the people of Snohomish County:

REPORT OF THE GRAND JURY.

We are under obligations to County Treasurer Cathcart and County Auditor Plackett for courtesies extended, and desire to express our cheerful appreciation of the efforts of Sheriff Stretch to provide for us and make us as comfortable as possible during our proceedings.

We would recommend, from the knowledge we have obtained, that an expert be employed to make a thorough examination of all the county records.

Having finished all the business that has come before us, we ask to be discharged.

T. B. NEELY, Foreman.

As the Grand Jury in its report has failed, "for lack of time," to enter into details in regard to the accounts of the Sheriff, we will, in justice to ourselves and the honest tax-payers of the county, endeavor to lift the veil of

NEWS OF THE NOR...

Items of Interest from Our E... Down for THE E...

New settlers in Southe... cultivating rice.

Yakima's big irrigati... been commenced.

No less than five seduc... pending in Victoria.

The Governor of Dako... the woman's suffrage bil...

Three excursions from... visit Puget Sound this s...

It is rumored that Gov... appoint C. H. Lewis o... the position of U. S. Se...

CLIPPING FROM THE *EYE*, 1885. The story in the left column, about a successful trial run of the Tompkins ferry, begs the question, what happened to the ferry service that Ferguson and Cady were permitted to build in 1861? Two months later, the *Yakima* steamship "collided with the ferry cable," but that it was repaired in quick order using the "old method" of attaching the cables.

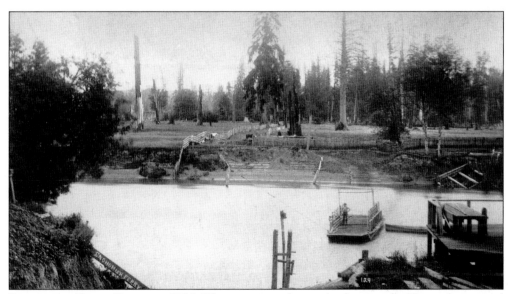

SNOHOMISH RIVER FERRY, C. 1885. This view is to the south, showing the Harvey homestead across the river. Young Noble Harvey and his canoe were for hire, ferrying people and cargo across the river around the same time. In 1888, A. H. Eddy was given a contract to build the first bridge in this location, and his all-wood bridge was finished in 1891. (RI-005.)

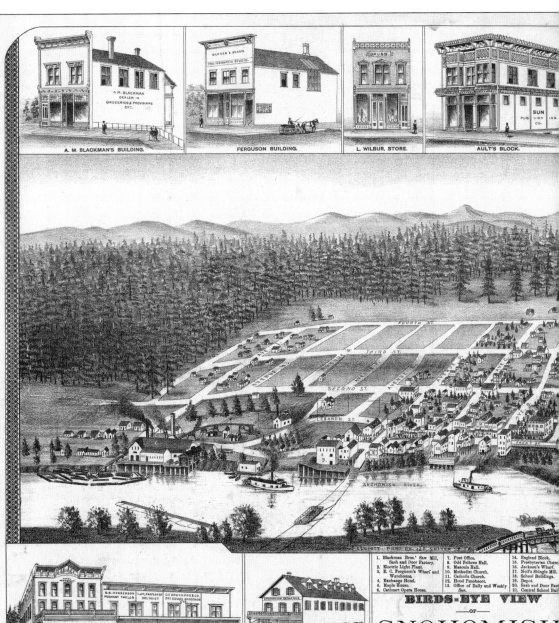

A. M. BLACKMAN'S BUILDING.

FERGUSON BUILDING.

L. WILBUR, STORE.

AULT'S BLOCK.

HOTEL PENOBSCOT.

BLACKMAN BLOCK.

J. E. FRANK, PROPRIETOR.

1. Blackman Bros.' Saw Mill, Sash and Door Factory.
2. Electric Light Plant.
3. E. C. Ferguson's Wharf and Warehouse.
4. Exchange Hotel.
5. Maple House.
6. Cathcart Opera House.
7. Post Office.
8. Odd Fellows Hall.
9. Masonic Hall.
10. Methodist Church.
11. Catholic Church.
12. Hotel Penobscot.
13. Office of Daily and Weekly Sun.
14. England Block.
15. Presbyterian Church.
16. Jackson's Wharf.
17. Noll's Shingle Mill.
18. School Buildings.
19. Depot.
20. Sash and Door Factory.
21. Central School Building.

BIRDS-EYE VIEW
—OF—
SNOHOMISH
WASHINGTON.
ISSUED BY THE
SUN PUBLISHING COMPANY.

Snohomish, Washington.
THE GEM CITY OF PUGET SOUND.

This town and the country in its vicinity was first settled in 1859. No families came here before 1864. It was made the county seat of Snohomish County in 1861. The first settlers were all single men. Before 1872 only some three or four families lived here. All the really valuable buildings have been put up since 1870. The first school was taught here in 1869. Since 1872 improvements have gone steadily forward and population has increased, until a year ago over 1,000 people resided in this place and its immediate vicinity. The building of the Seattle, Lake Shore and Eastern Railroad from Seattle, the metropolis of Puget Sound, to this place last year, started a genuine boom. Property advanced from 200 to 300 per cent in value, and last fall the population was over twice as great as the spring before. During the past winter many newcomers found permanent homes in the surrounding country, and perhaps there was no considerable increase of population in the town from December to April. Now immigrants are coming in rapidly, and the town population is steadily increasing. The population of the town proper is now nearly 2,000. In Snohomish Precinct, which includes the town and

the region of country in its immediate vicinity, there is now a population of nearly or quite 3,000 people. For its size and age this is the best built town in Washington. Should the great immigration expected the coming fall really reach us, it would not be surprising to find 3,000 people in the town, 5,000 people in Snohomish Precinct, and 10,000 people in Snohomish County, before Jan uary 1st, 1890.

Now, what has built up this town? What is there to maintain a large population? What are the interests and resources of the place? Besides being the county seat of a prosperous, growing county, it is the center of immense timber interests and extra fertile and productive farming lands. Each are mainly found on different classes of land. Yet more valuable lumber interests center at this

place than at any other point in Washington; while the town is the center of more extra fertile bottom land than any other town on Puget Sound. For many years the logging interests took the lead, the cost of clearing and improving the farming lands having made such improvements to go slow at first. Now that stage is past, and farming is a leading interest, and farm improvements are being rapidly made.

Each year, for nearly twenty years past, many valuable buildings, for both residence and business purposes, have been erected; but last year and this a veritable building boom has been going on. During the past fifteen months one hundred residences and business houses have been built. Since January 1st some forty residences and nearly a dozen business buildings for stores and manufactories have

been put up, some of them very valuable. Should present plans be carried out, over $200,000 worth of improvements will be made the current year.

The manufacturing interests have a progress. During 1889, the total value of manufactured products, as lumber, doors and blinds, furniture, wood ware, will amount to about $400,000 in value. Two hundred men find employment here in the mills and shops, and as carpenters, painters, and skilled mechanics generally are actively engaged as teamsters, freighting, etc. About 500 men work as lumbermen, in regions tributary to the town, most of whom claim Snohomish as their home, others are employed in clearing land, grubbing

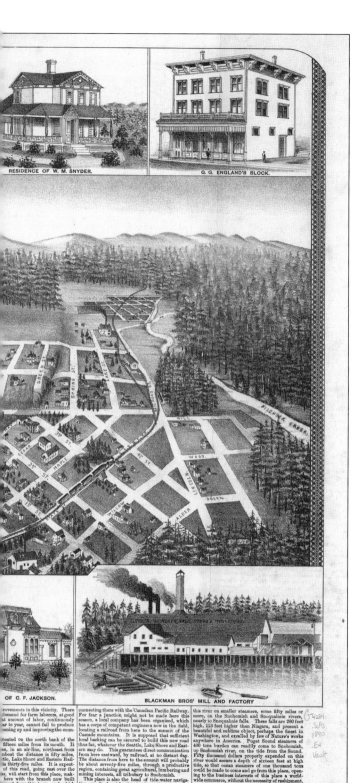

RESIDENCE OF W. M. SNYDER.

G. G. ENGLAND'S BLOCK.

OF C. F. JACKSON.

BLACKMAN BROS' MILL AND FACTORY.

rovements in this vicinity. There demand for farm laborers, at good amount of labor, continuously ar to year, cannot fail to produce ening up and improving the coun-

cated on the north bank of the fifteen miles from its mouth. It es, in an air-line, northeast from about the distance is fifty miles, tle, Lake Shore and Eastern Rail-a thirty-five miles. It is expect-of this road, going east over the es, will start from this place, mak-here with the branch now built ward from this town, and which extended into British Columbia,

connecting there with the Canadian Pacific Railway. For fear a junction might not be made here this season, a local company has been organized, which has a corps of competent engineers now in the field, locating a railroad from here to the summit of the Cascade mountains. It is supposed that sufficient local backing can be secured to build this new road thus far, whatever the Seattle, Lake Shore and Eastern may do. This guarantees direct communication from here eastward, by railroad, at no distant day. The distance from here to the summit will probably be about seventy-five miles, through a productive region, containing great agricultural, lumbering and mining interests, all tributary to Snohomish. This place is also the head of tide-water naviga-tion on Snohomish river. An active steamboat trade is down this river, to Puget Sound, and up

this river on smaller steamers, some fifty miles or more, on the Snohomish and Snoqualmie rivers, nearly to Snoqualmie falls. These falls are 280 feet high, 113 feet higher than Niagara, and present a beautiful and sublime object, perhaps the finest in Washington, and excelled by few of Nature's works anywhere in America. Puget Sound steamers of 400 tons burden can readily come to Snohomish, up Snohomish river, on the tide from the Sound. Fifty thousand dollars properly expended on this river would secure a depth of sixteen feet at high tide, so that ocean steamers of one thousand tons could be made to come and go from this place, open-ing to the business interests of this place a world-wide commerce, without the necessity of reshipment, as at present. This improvement will be made at no distant day.

ELDRIDGE MORSE.

BIRD'S-EYE VIEW OF SNOHOMISH, 1890. This endlessly useful lithograph features thumbnail sketches showing early Snohomish buildings for which there are no photographic record. For example, the Ferguson Building (top, second from left) was located on the southwest corner of Avenue D and Second Street and had an expanse of glass for a photograph studio. At bottom left is a sketch of the Penobscot Hotel as part of the Blackman block, which is included in the background of the image on page 75. The population at the time was 2,000 in the town proper, and the text, by Eldrige Morse, cites the "immense timber interest and extra fertile and productive farming land," as responsible for maintaining this large population. (Courtesy Library of Congress, G4284.S6A3 1890.)

67

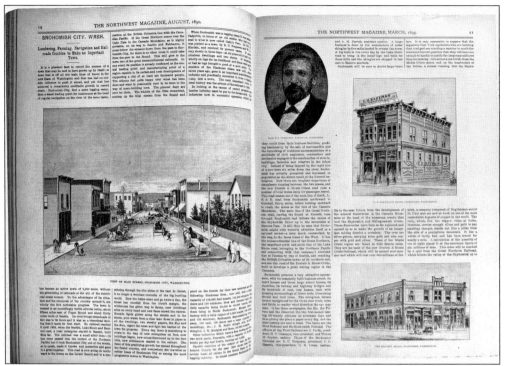

NORTHWEST MAGAZINE, 1890/1893. The author has combined pages from two articles about Snohomish appearing three years apart in this large-format magazine published by E. V. Smalley in St. Paul, Minnesota—which at that time was considered the Northwest.

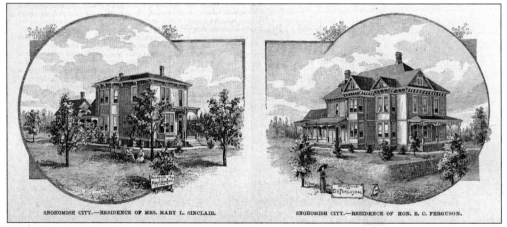

ILLUSTRATIONS IN NORTHWEST MAGAZINE, AUGUST 1890. Along with the rails came the national promotion of westward migration by train. The uniqueness of Snohomish was a common theme: "At first a mere logging camp with a small trading post at the head of river navigation, it had become an active town, without the aid of the outside real estate boomer." (UW, 979.505 sm v8.)

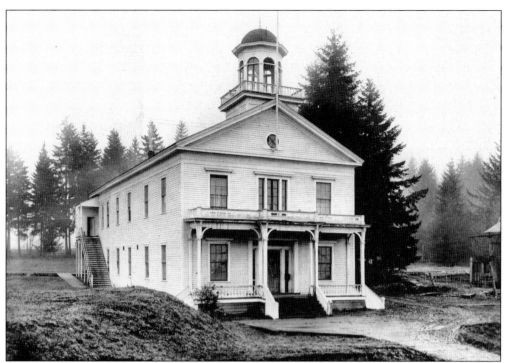

FIRST WASHINGTON STATE CAPITOL BUILDING IN OLYMPIA, 1902. When statehood was established on November 11, 1889, Snohomish County's population was around 6,000 white settlers, most of whom lived along the river. Snohomish City was the economic and cultural center, with the county's only bank, newspapers, schools, associations, and churches; and now it offered easy access to points south by train. (A. Curtis, UW, ACurtis01403.)

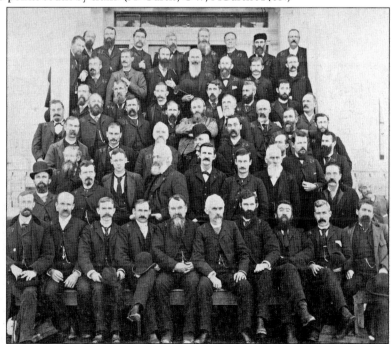

FIRST HOUSE OF REPRESENTATIVES, WASHINGTON STATE, 1889. A. H. Eddy from Snohomish is in the second row from the top, second man from the left. Eddy was in the process of building the first bridge across the river at Avenue D, between trips to Olympia. (Courtesy Middy Ruthruff.)

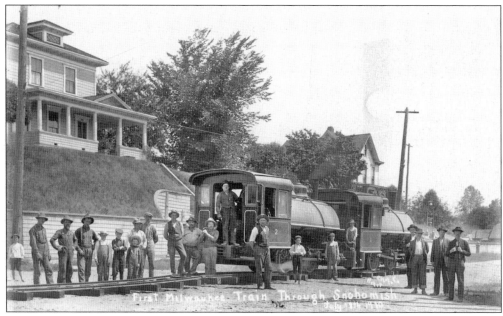

FIRST MILWAUKEE TRAIN, 1910. This photograph shows the installation of tracks down Second Street. Work has been stopped for Lee Picket's camera between Avenues A and B. That is Lot Wilbur's house in the background, and the hill upon which it sits was removed in the 1940s for an automobile dealership. (Picket, CE-002.)

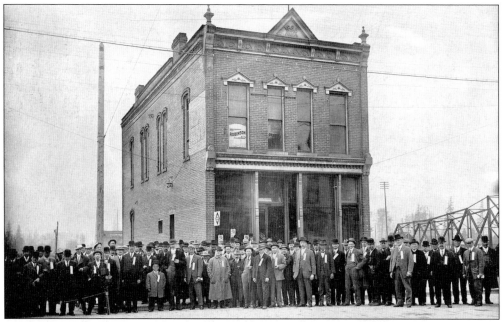

GOODWILL TOUR, 1912. "You can't miss Snohomish if you come over the Milwaukee," read the white ribbons worn by the men. They are posed in front of the former Wilbur building, the depot for the new Milwaukee Railway. The event was advertised as a "stag affair" for members of local commercial clubs to inaugurate passenger service. (CE-003.)

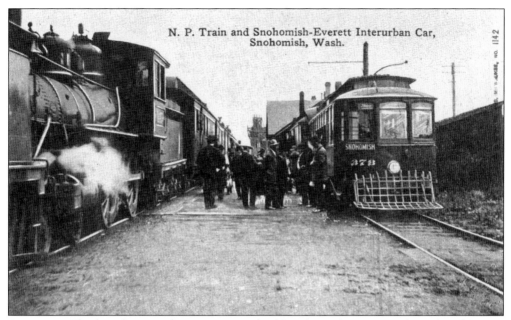

POSTCARD. The first electric railway service north of Seattle was between Snohomish and Everett beginning in 1903. The 6-mile line ran through Lowell over Northern Pacific tracks and took about 30 minutes.

REVERSE, POSTMARKED 1913. Around 1910, when Everett was "dry" and Snohomish "wet," Everett men invaded Snohomish on Saturday nights for alcohol, and the last train at midnight became known as "The Sponge." (RR-004.)

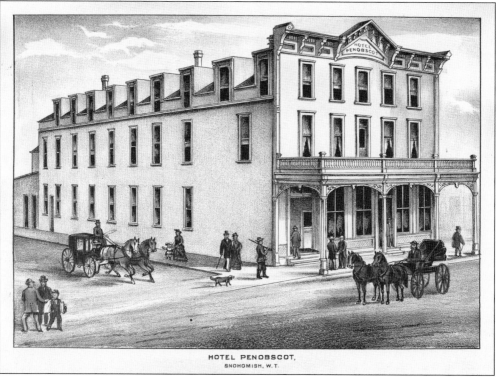

HOTEL PENOBSCOT,
SNOHOMISH, W. T.

Hotel Penobscot, Lithograph, 1890. Philip Van Buskirk, then retired from the U.S. Navy, wrote in his diary in 1896: "Occupy tonight room 47 in the Penobscot Hotel. It is a big front room for which the charge is 75 cents, with better sense and less vanity I would have taken a 50 cent room, smaller but every bit as comfortable." (UW, 979.505 sm v8.)

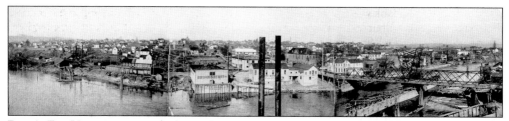

Bird's-Eye View, c. 1891. The bird taking in this view would have been perched on the roof of the Snohomish Dairy Products Company, owners of the twin smokestacks. The suspicion from this historical perch is that the motivation for this triptych panoramic photograph was to show off the brand-new wooden bridge crossing the river at Avenue D. (SG-001n.)

Five

BUTCHERS, BAKERS, AND ONE CIGAR MAKER

Boasting about Snohomish City's entrance into the modern age of the 1920s, William Whitfield diminishes the bloom of the boom year 1889: "Snohomish . . . maintained only two churches and one grade school although there were twenty saloons in the principal business district, no pavements, a few boarded sidewalks, all homes fenced in, stumps and down-timber everywhere and live stock roaming at large, while the county and city jail occupied a central place on the main street."

Yet the historical society's collection of business images from this era is the largest section by far, and they provide powerful testimony to the tremendous growth of Snohomish once the train arrived. Improvements to the town were valued at $200,000, not including $20,000 for additions to the Snohomish Electric Light Company, established in 1888, or $5,000 for the waterworks, which began distributing water from today's Blackman Lake the previous year. The value of products manufactured in Snohomish topped half a million dollars. New concerns at this time included a sash-and-door factory, a brick-and-tile works, and a cigar factory, where it was reported in *River Reflections* that "the 'manufacturer' used the tongue to supply the needed moisture to seal the edges of the leaves."

The First National Bank was established in 1888—housed in the first brick building in the county. Two years later, Lot Wilbur erected the second, next door, for the manufacture of his growing line of home remedies. Like Wilbur's historical reputation, his building is still standing.

And with the railroad came the need for a four-star hotel, a need met by Blackman's three-story Penobscot Hotel, which opened on May 23, 1888. This date should be noted as the beginning of Snohomish's life in the shadow of a young town growing to the west, founded by men bringing money from the east—the same money that paid for their individually heated rooms, the largest ones facing First Street. The nascent town was named after one of their sons, Everett.

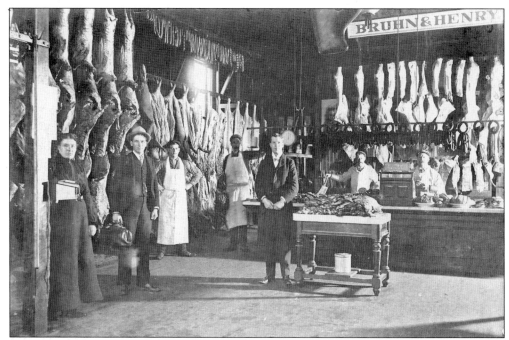

BRUHN AND HENRY MARKET INTERIOR, C. 1890. Robert Henry came to town with the railroad construction crews, supplying them with groceries and meats. A few years later, his brother William joined him as a meat cutter. That is William in the center of this composition, dressed as the co-owner he became in later years. Bruhn was a silent partner and never lived in Snohomish. (BU-014.)

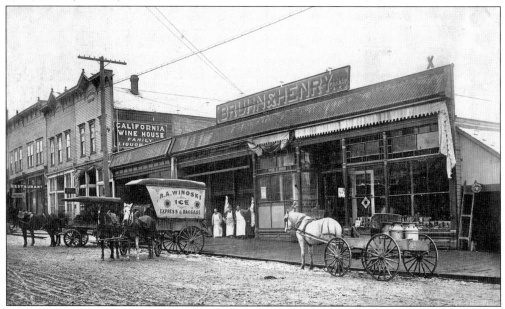

BRUHN AND HENRY MARKET EXTERIOR, C. 1890. This store was located on the corner of First Street and Avenue B, on the south or river side—very useful for deliveries by steamship. First Street is still a dirt road in this image, which means it was captured before 1892, when it was "paved" with 3-inch-thick planks. (BU119.)

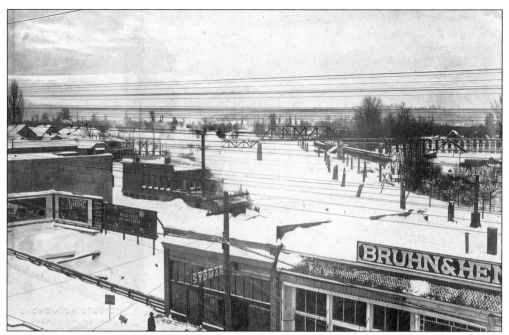

WINTER SCENE, C. 1905. This is a pretty picture, but a frozen river meant a freeze to the flow of goods. The second structure from the left is the rarely photographed Laundry Steam Plant, which was destroyed by fire in 1908. A smaller plant was built on this site after the Chinese laundry on Avenue B was blown up in 1885 (see page 28). (Snohomish Studio, FS-027.)

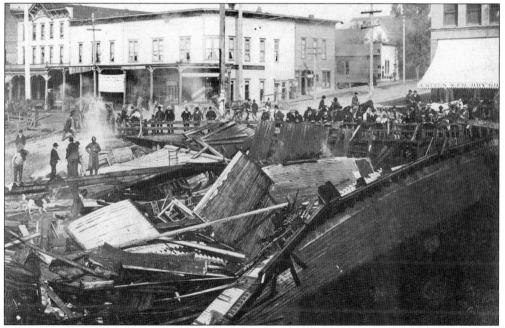

BRUHN AND HENRY MARKET RUINS. Issues of the *Snohomish County Tribune* for the last six months of 1908 are missing, where one could probably learn more about this image. Meanwhile, enjoy the rare photograph of the Penobscot Hotel in the background, barely included on the left—it too was destroyed, by fire in 1911. (FI-001.)

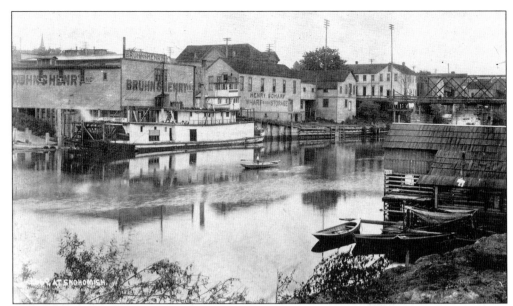

No. 669 at Snohomish, c. 1900. A numbered photograph usually indicates that it is the product of a professional photographer hired by a railroad survey team. The small boy in the flat-bottomed riverboat could have been the young Noble Harvey working the river when there was no bridge at Avenue D, shown here on the right. (FS017n.)

Bruhn and Henry Wharf, c. 1900. This photograph demonstrates another advantage of finally having a bridge across the river—the professional photography studios in town could use it for capturing dramatic overhead shots of their productive and organized clients. (Fowzer, BU-015.)

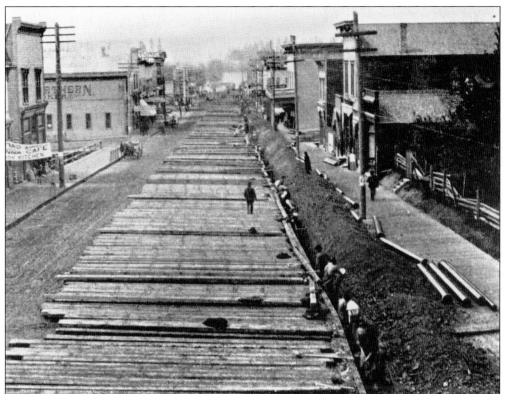

No. 73 Laying Water Main in First Street, 1892. Anders Wilse was a professional photographer from Norway who was working for a survey team with the Great Northern Railroad when he took this photograph of First Street, looking toward the river, on April 29. Along with installing a water main, it appears the street will also be "paved" with planks. (Wilse, MOHAI, No. 11,006.)

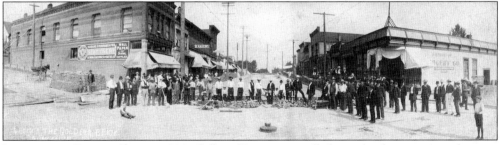

Laying the Golden Brick, 1908. Gilbert Horton was called upon to document another stag affair: this one marked the laying of the first gold brick at the intersection of First Street and Avenue A. Completing the job of paving First Street with brick resulted in a three-day party with no-host bars at all of the saloons. (Horton, CE-001.)

M&M Saloon, c. 1900. Martin Zaepfel came to Snohomish in 1890 and was employed as a carpenter. On November 26, 1904, he and A. G. Micheel sent out engraved invitations to the grand opening of this saloon on First Street. The owners are probably in this picture, but unfortunately none of them have been identified. (Snohomish Studio, BU-104.)

Palace Restaurant, 1912. Unidentified employees are ready for customers in this dignified-looking restaurant, complete with white tablecloths, owned by Gilmore and Oscar Jurgens. Most striking is the tile floor, which was probably done with tiles manufactured at Snohomish Brick and Tile Company. (BU-078.)

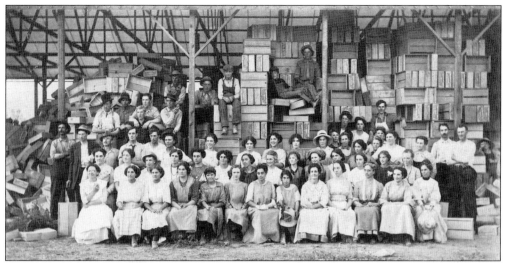

THOMPSON FRUIT CANNERY. This well-composed photograph of unidentified employees shows that cannery work was a woman's job. Since the climate and soil conditions were excellent for growing fruit, many small, family-run cannery operations resulted, some lasting into the 1960s. (BU-158.)

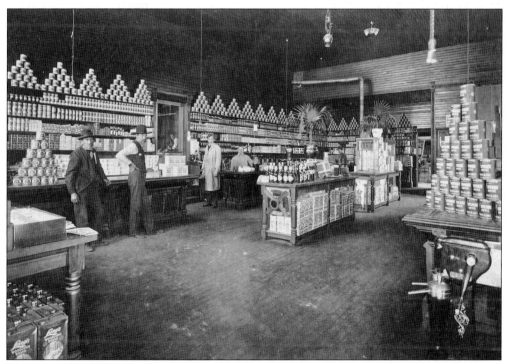

UNIDENTIFIED GROCERY STORE INTERIOR. E. C. Ferguson's son, Cecil, and his wife, Clara, founded the Ferguson Canning Company in 1914, and it wasn't even incorporated until 1959. Since the fruit season lasted only four months, they expanded to preserve corn, smoked fish, and even clams in cans. (BU-159.)

E. C. Ferguson and Office Exterior, c. 1900. The Fergusons drew up the western plat for the town site on June 21, 1871. It provided for streets numbered First, Second, and Third; and four avenues, A, B, C, and D, plus Union. The eastern plat, filed by the Sinclairs, added Commercial Street, parallel with the river, and the cross streets Cedar, Maple, State, Willow, and Alder. (BU-025.)

E. C. Ferguson and Office Interior, c. 1900. Ferguson worked real estate deals out of this office for 23 years, until his death in 1911. (BU-027.)

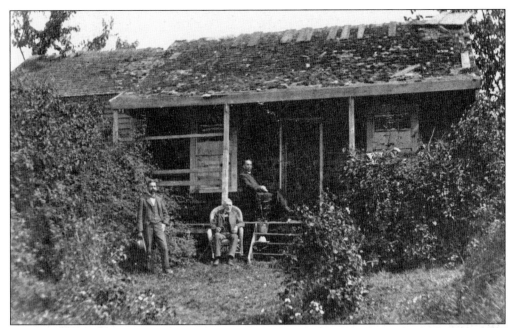

FERGUSON COTTAGE, C. 1900. Ferguson is seated in front of the house he built for himself nearly 50 years earlier. Behind him, sitting on the porch, is James Burton, and standing is M. J. McGuiness, the owner of the property at this time, who moved the structure a short distance in order to build on this prime site overlooking the river. (PE-508.)

FERGUSON COTTAGE, 2007. Rebecca Loveless (standing) purchased the cottage in 1997 not knowing that she had just bought the oldest house in the county. Sheryl Maultsby (seated) committed to renting the house at first sight, even in its rundown condition, then waited patiently until she could move in, nearly 10 years ago. (Blake, courtesy Rebecca Loveless and Sheryl Maultsby.)

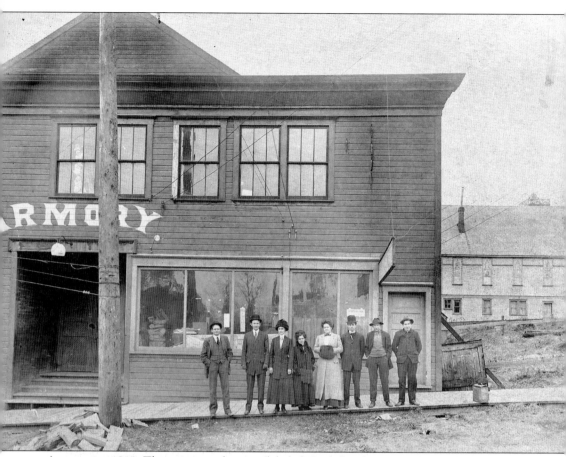

ARMORY, C. 1910. This structure shows up labeled "Built for Skating Rink" on the 1897 Sanborn insurance map, and by 1905, its label has changed to "Dance Hall (very cheap)." A National Guard unit was formed around the same time, and it first used the abandoned Cathcart Opera House for drills. In September 1906, public money was allocated to retrofit the old skating rink–dance hall into an armory for Company C of the state guard. It was the armory until a new one was built across the street on Union in 1928. This writer's oral history research confirms that it reverted back to use as a skating rink and was a very popular dating destination well into the 1930s, when it was torn down to build a new post office in 1938. That is St. John's Episcopal Church (1894) in the background, and the unidentified persons lined up out front might be employees of the *Snohomish County Tribune*, as indicated by the sign in the window. (BU-036.)

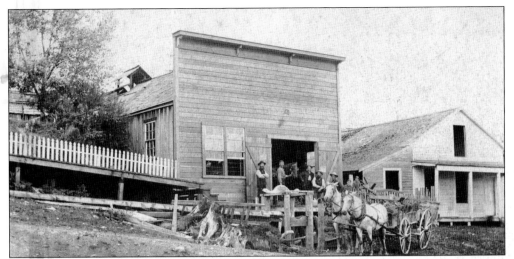

BLACKSMITH SHOP, C. 1890. Located south of First Street, toward the river and on the east side of Maple Street, this business is the heart of old Cadyville. It might have been the Hansen family business since on the left is L. Hansen and the last two people on the right are identified on the reverse as Mrs. Hansen and her daughter Matilda. (Horton, BU-074.)

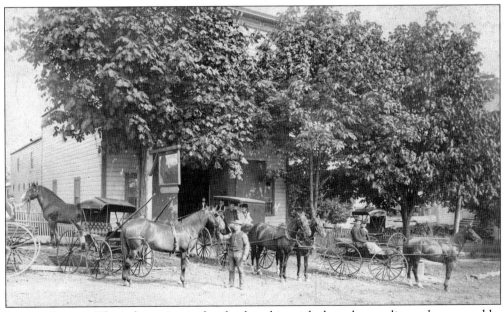

LIVERY STABLE. The information is sketchy, but this might have been a livery shop owned by Tam Elwell. Since it has been given a professional presentation on card stock, and because the composition is so perfect, this photograph could have been used as promotion for the livery business where people rented a horse and buggy as needed. (Barnes and Evans, PE-657.)

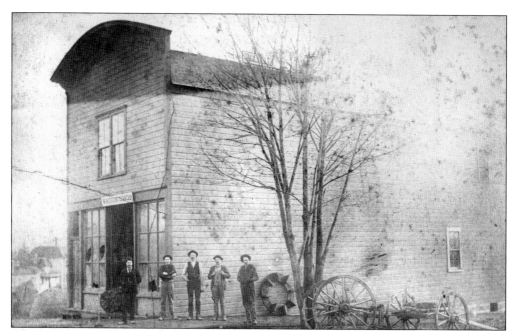

KNAPP WAGON SHOP, C. 1890. This business was located at Second Street and Union Avenue, and the name Knapp shows up quite frequently on lists of members of civic commissions and community organizations. From left to right are A. C. Carpenter, L. A. Carter, Ora C. Knapp, Pat Coffee, and Cyrus H. Knapp, who served as both a city council member and fire chief. (Northwest Room.)

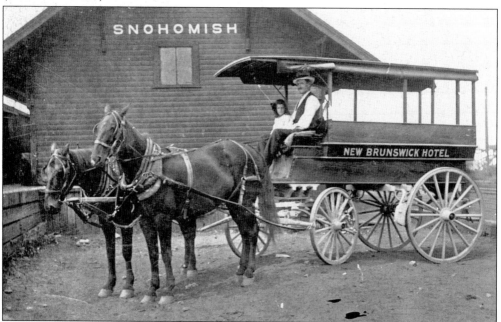

NEW BRUNSWICK HOTEL WAGON. The Knapp Wagon Shop may well have built this handsome wagon, but not even the names of the people pictured in the wagon have been handed down. Since this is a postcard, though, it must have served as promotion for the hotel. The depot-like structure in the background has not been identified either. (BU-157.)

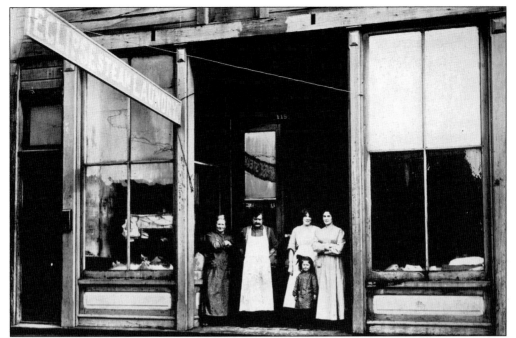

ECLIPSE STEAM LAUNDRY. A steam laundry plant was built where Avenue A meets the river after the Chinese laundry operation was blown up in 1885 (see page 28). Stores such as these were probably retail outlets for the large laundry plant. (BU-080.)

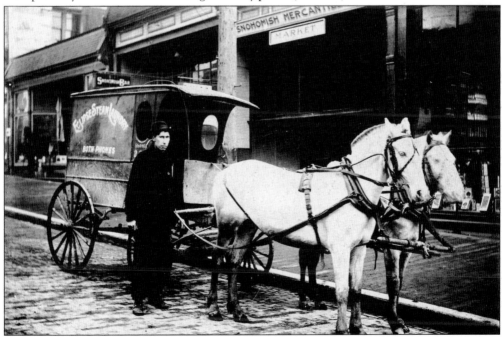

ECLIPSE STEAM LAUNDRY DELIVERY WAGON. The historical society has so many images of horse-drawn carts that the subject could have had its own chapter. This one was selected to represent the collection, not only because it goes with the store pictured above but also because it shows two horses doing the job usually pictured as pulled off by one. (BU-081.)

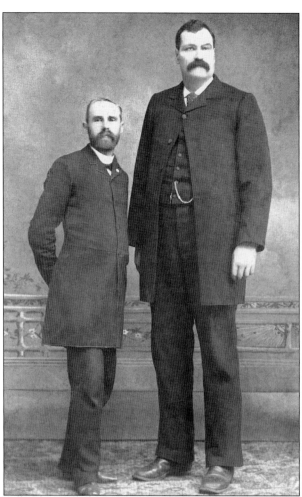

SIEWERT AND MILLIGAN, 1892. The photographer Herman Siewert (left) had a studio in Everett. Jonathan Milligan was 6 feet, 4 inches tall and a good sport. Also on the reverse is the stamped name Bobo's Studio, Snohomish, Washington. (Siewert-Barnes, PE-028.)

PORTRAIT, 1904. The person on the left is not identified, but in the center is Rex Alexander, and Claud Haskell is on the right. Alexander went on to become a professional magician, a path he may have already decided to follow when this portrait was taken. Remember, it was the era of Harry Houdini (1874–1926). (PE-138.)

STUDIO PORTRAIT OF CECIL FERGUSON, C. 1900. This is E. C. Ferguson's only son, born in 1881, and he looks to be about 10 years old in this portrait—a very confident look is upon the face of a well-poised young man. Cecil went on to establish the Ferguson Canning Company with his wife, Clara (see page 79). (PE-100.)

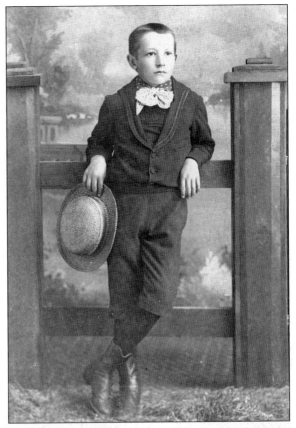

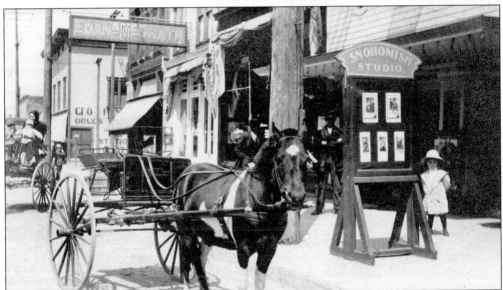

SNOHOMISH STUDIO. Looking at store signs in photographs of First Street, there is an abundant number listing "Photographer," so it seems to have been a popular business activity in early Snohomish. All four buildings from the right are still in use, and the cross street in the background is Avenue A. (BU-073.)

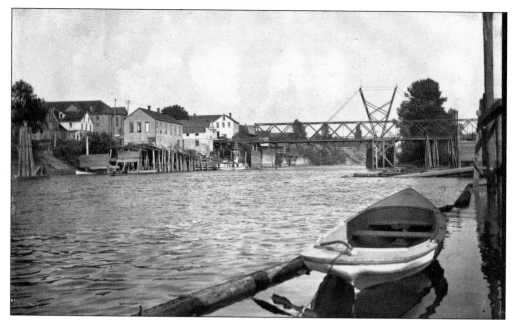

LOOKING UPRIVER. The bridge crossing the Snohomish River turned on a center mechanism in order to allow for steamship traffic. The plans were presented to the new council of a newly incorporated Snohomish in 1891, estimated to cost $14,000, a bargain compared to $43,000 for the new water system contract. At this time, Ferguson alone was paying one-eighth of the taxes collected in Snohomish. (RI-032.)

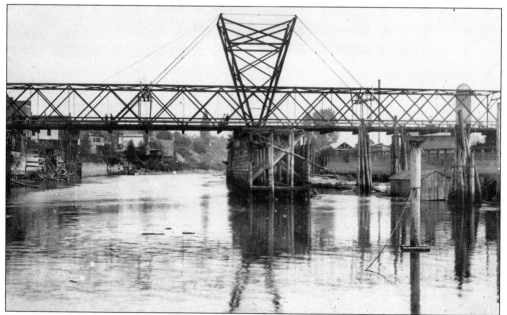

FIRST AVENUE D BRIDGE, C. 1891. City politics swung between the Populists and the Non-Partisans, to use Whitfield's terms, but it seems to have come down to the friends of Hyrcanus Blackman versus those of Emory Ferguson. While H. Blackman is listed as the first mayor of an incorporated Snohomish, a second election held in the same year gave the seat to E. C. Ferguson. (RI-007.)

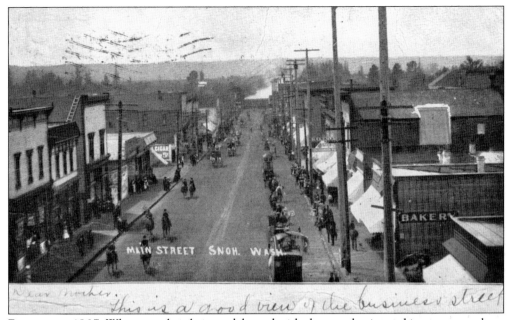

POSTCARD, 1907. What exactly is being celebrated with the parade pictured is a mystery; also a mystery is where the photographer was located to get this aerial perspective. Note the alignment of First Street with the Snohomish River, a vista concealed by new-growth trees. (FS-006.)

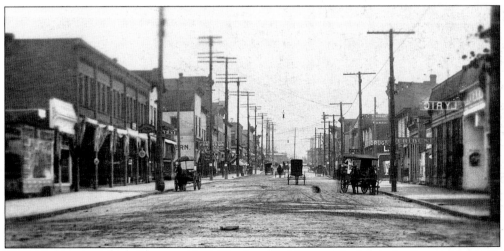

FIRST STREET LOOKING EAST, C. 1905. The large building on the left is the Brunswick Hotel, which remains in use as studio apartments. Most of the buildings on the right, however, were vacated in the 1950s because of foundations weakened from continuous flooding and finally destroyed. Since 1966, one block has been a parking lot and the other a riverside park. (FS-000.)

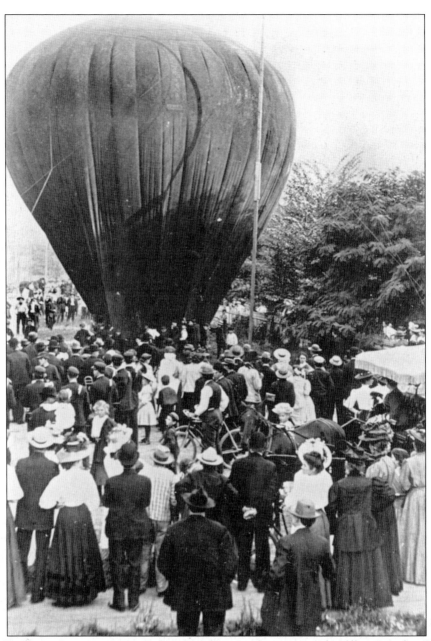

SMOKE BALLOON LAUNCH, 1908. Before propane, straw fires were used to fill an "envelope" staked to the ground with hot, smoky air. Once the envelope was straining at the ropes, an aeronaut would strap himself into a harness and give the command to his assistants to chop the ropes and set him free. The rig would rise at a rapid speed to a couple thousand feet above the crowd. At this point, the aeronaut released himself from the harness and began a free fall back to earth, holding a rope that inverted the envelope, releasing the hot, black smoke for dramatic effect. Eventually the aeronaut opened his parachute and usually landed safely, to the wild cheers of the audience. In 1944, Noble Harvey and his son Eldon, along with others, established the Harvey Airfield, and it is still a rare family-owned airfield. Eldon's daughter, Marilyn, has operated the Airial Hot Air Balloon Company at Harvey Airfield since 1981. (CE-032.)

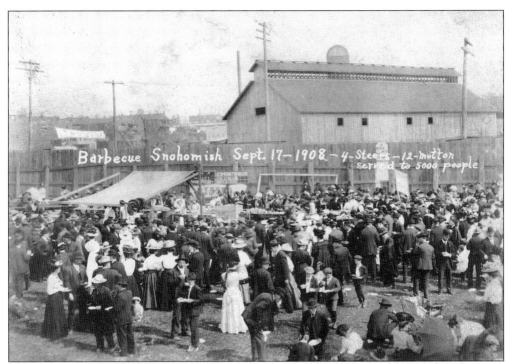

BARBECUE SNOHOMISH, 1908. The photographer's inscription says it all except for the occasion. Since this event is taking place on the fairgrounds, perhaps it was the county fair. The fairgrounds and ballpark were located on the Harvey homestead, and that is his barn in the background. Peeking over the top is the silo belonging to the lumber mill. (CE-014.)

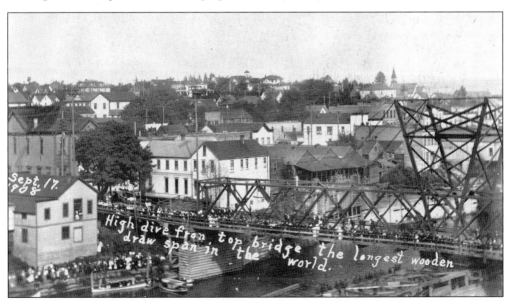

HIGH DIVE, 1908. "The longest wooden draw span in the world that rarely worked" would be a more accurate description of this bridge, since it was always breaking down. As for the high dive attraction, "There are boys in this town who have and will do the same turn every day in the week for nothing," reported the *Tribune*. (Crown Studio, CE-012.)

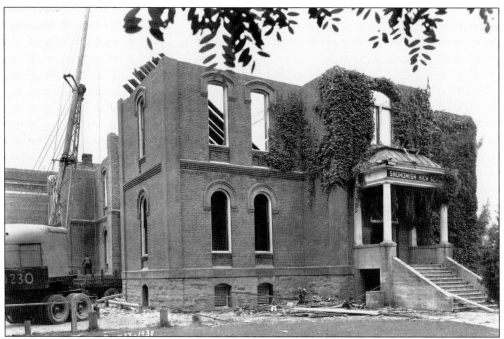

HIGH SCHOOL DEMOLITION NO. 1, 1938. The editorial in the *Tribune*, June 16, 1938, is titled, "Making Way for Progress." The second paragraph concludes, "First as a courthouse for Snohomish County, then as a small college, and finally as a high school, it has been intimately connected with the life of every family in the district." (Kleppinger, SB-035.)

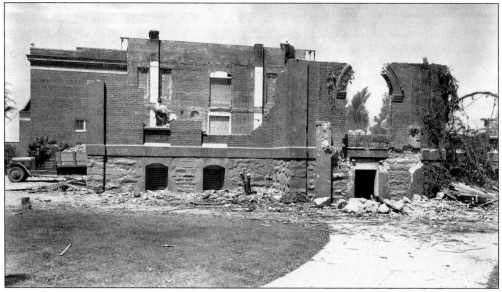

HIGH SCHOOL DEMOLITION NO. 2. Skipping a line about creating good citizenship, the editorial continues, "Thus there is much sentiment connected with the bricks and mortar the wreckers will start disturbing next week, but we must forget sentiment when we think of the beauty and utility of the structure which will replace it and house future generations of young Snohomishites." The courthouse/high school building was located on Avenue D and Seventh Street. (SB-039.)

Six

THE COURTHOUSE AND OTHER LOSSES

With the opening of the new decade of 1890, the "Mother City" of county civilization was so broke that restaurants were refusing to extend anymore credit for even prisoners' meals. Voters failed to approve a bond issue for the new courthouse, so the commissioners issued their own bonds and built a beautiful two-story courthouse on land donated by the Ferguson brothers on Avenue D. A majority share of the $24,000 cost stayed in town with the purchase of brick from the Bast Brickyards. County records were moved into the impressive building in 1891.

By midyear, the smallpox epidemic reached panic stage when Seattle threatened a quarantine against the county—probably by long-distance telephone on wires just strung that summer by the Sunset Telephone Company. Then mid-decade, the streetlights were cut off until a new contract could be worked out with the light company—not a good situation for a town often overwhelmed with a deadly mix of too much alcohol and lonely testosterone.

The city council failed to be swayed by 677 signatures of Snohomish citizens on a petition to revoke the license of the notorious Gold Leaf Saloon. Located east of downtown, on the wrong side of the newly laid tracks, the Gold Leaf was one of many downtown establishments dedicated to separating loggers from their wages. To end the discussion with a drunken customer one night in 1897, owner William Wroth shot William Kinney three times, once in the heart, and he died in the street, two hours after midnight. A jury that included historian William Whitfield acquitted Omaha Bill on the grounds of "justifiable homicide." But the incident caused "steps to be taken to check vice," wrote Whitfield.

Also happening in the middle of one night in 1897, thirty-seven horse-drawn wagons were loaded with the courthouse records and caravanned to Everett, like a "funeral procession," reported the newspaper. Snohomish had lost the county seat but the citizens adapted, like the beautiful courthouse, which found immediate use as a private academy and later as the public high school until 1938.

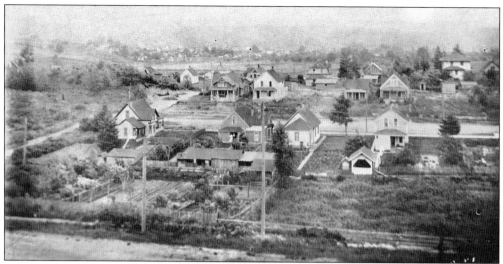

COURTHOUSE TOWER VIEW EAST, C. 1900. At the bottom of the image is Avenue D, so Avenue C is the next street over, and the cross street on the left is Sixth Street. Several of the houses on Avenue C still exist, while the lovely gardens are now parking lots in service to the many businesses that line a modern Avenue D. (HS-191.)

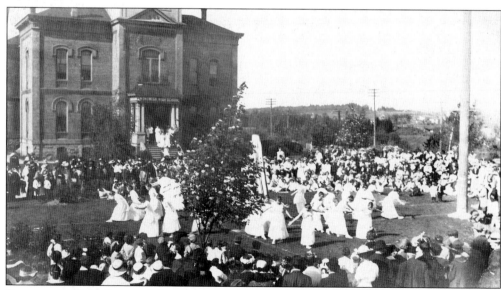

SNOHOMISH HIGH SCHOOL MAY DAY, 1910. May Day balls were a tradition in early Snohomish, and it seems the young women attending Snohomish High School continued the annual celebration. Evidently it was very popular, judging by the crowd in this Kodak moment; but a news story in 1917 reported that the time should be changed from afternoon to evening so that more workingmen could attend. (RC-085.)

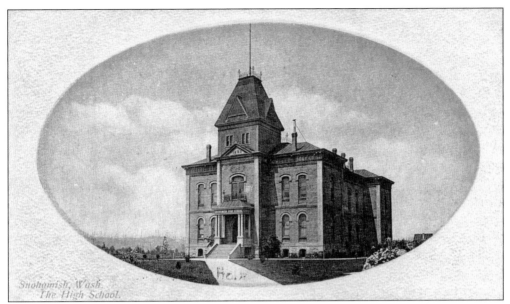

POSTCARD. This is a glossy, embossed postcard, manufactured in Germany, purchased in Leavenworth, Washington, and sent to the correspondent in Seattle. A high school education at this time was considered the poor man's college, so did the writer select this expensive card because he or she wished to attend high school?

REVERSE, POSTMARKED 1913. Or was it the picture of a dream—of a building built by hand, brick upon brick, that captured this person's imagination? After all, the postcard writer had just taken a job in a brickyard, and the image could have spoken for the writer of a positive future working on such a fantastic structure someday. (SB-002.)

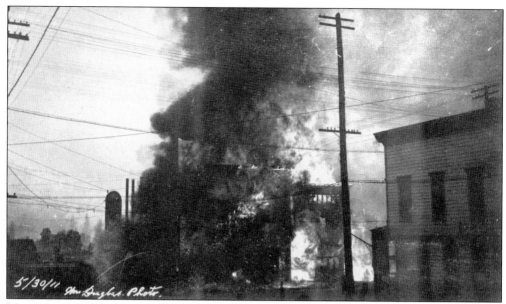

MAY 30, 1911. "DISASTROUS FIRE VISITED SNOHOMISH TUESDAY" read the headline in Friday's *Tribune*. Old news by then, but the subhead gave the details that people were looking for: "Thirty-five Business Places Wiped Out—Total Loss $150,000." The view is south from Avenue B, showing the Pioneer Restaurant consumed in flames. The origin of the fire was determined to be in the basement of this restaurant. (Douglas, FI-005.)

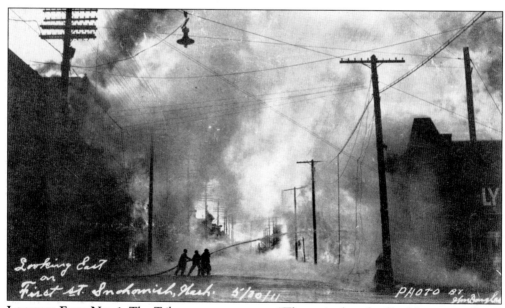

LOOKING EAST NO. 1. The *Tribune* went on to say: "The entire bunch of buildings were flimsy structures, all frame buildings, the rear of the entire block resting on timbers from ten to twenty feet high, as there is a sharp drop of this distance from the level of First Street to the river Bank. Back of this block is the new trestle work of the Milwaukee road which was badly burned." (FI-006.)

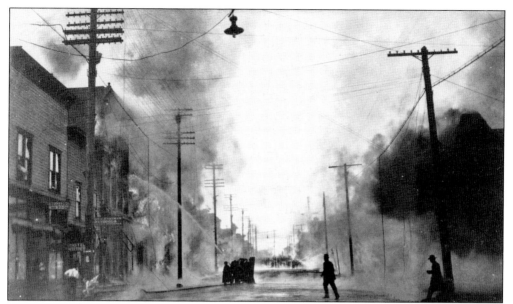

LOOKING EAST No. 2. "In thirty minutes after the fire was discovered it had leaped across the street to the old Blackman building in which were located the Post office, the Penobscot Hotel and other business places, which burst into flames so rapidly that the hotel guests barely had time to escape by the rear entrance, many of them losing all their baggage," reported the *Tribune*. The hotel is on the left. (FI-007.)

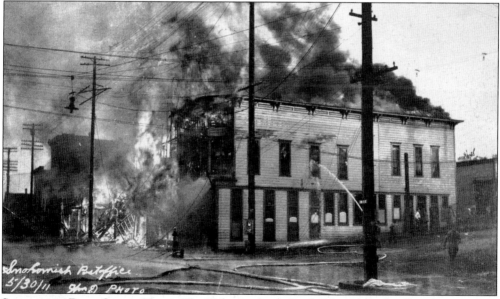

SNOHOMISH POST OFFICE No. 1. The *Tribune* editorialized, "Not a breath of wind was stirring [otherwise] the entire business portion of the city would have been wiped out. Heroic efforts on the part of our splendid volunteer fire department kept the flames confined. . . . that it was hot where they were working may be judged from the fact that part of their fire hose was burned in two while in use." (FI-003.)

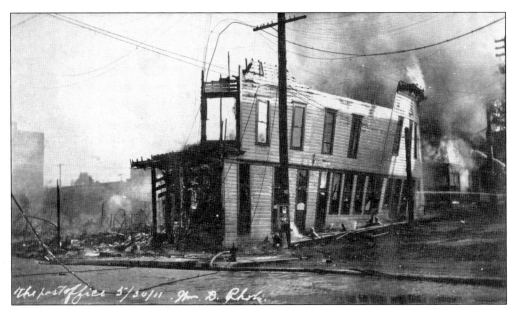

THE POST OFFICE NO. 2. Barely showing on the left is the three-story Schott's Building that acted as a firewall, stopping the westward movement of the fire. A new, $2,000 firewall between the Maple Saloon and Lysons Hardware Store on the south side of the street cracked and collapsed when water hit the overheated structure. (FI-004.)

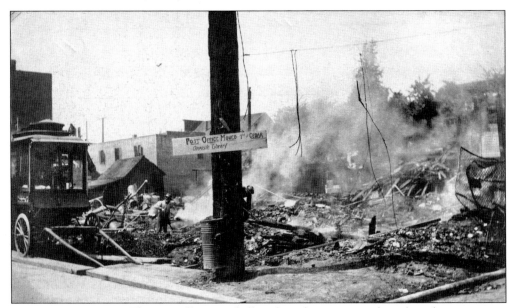

POST OFFICE MOVED. The post office saved all its furnishings except the safe and a wire screen that can be seen on the right. Estimated losses were listed in the *Tribune*, and for the post office it was $1,200, but it was fully insured. The Penobscot Hotel's loss, on the other hand, was $11,000, with only $2,300 covered by insurance. (FI-008.)

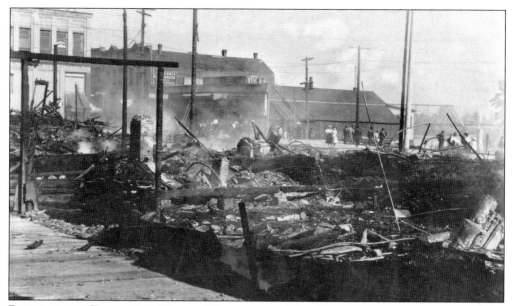

RUINS OF THE PENOBSCOT HOTEL. "Strenuous work by the fire department alone saved the Bruhn and Henry building which was situated on the corner of Avenue B, had this building caught fire the whole business section of the city would have been doomed," reported the *Tribune*. Visible in the background, from left to right, is the Otten store, Bruhn and Henry market, and the railroad bridge. (FI-010.)

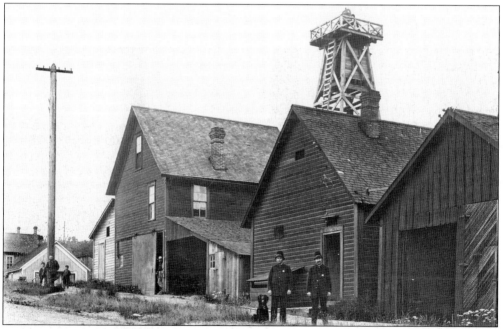

WATER DEPARTMENT, CITY JAIL, AND FIRE HALL, C. 1910. Dating from at least the 1890s, these three buildings were still in use in 1926 when they were the subject of a front-page editorial in the *Tribune* that included a photograph, calling them "in Dilapidated Condition After Years of Use." Located at the corner of Second Street and Avenue A, "every citizen should visit the structures pictured." (PO-007.)

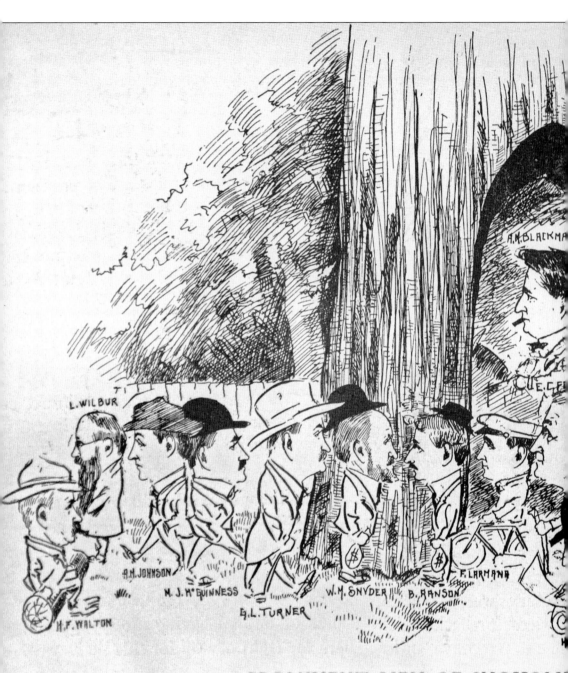

PROMINENT MEN OF SNOHOMI

Labels in illustration: A.H.BLACKMA / CUE.C.F / L.WILBUR / A.H.JOHNSON / N.J.McGUINNESS / G.L.TURNER / W.M.SNYDER / B.RANSON / F.LARMANA / H.F.WALTON

See America First Magazine, **1910.** This illustration accompanied a one-page article entitled "Snohomish the Home City" in a nationally distributed magazine created in 1800 to promote tourism. The author, H. N. Stockton (pictured center front), who wrote for the Everett *Daily Herald*, doesn't talk about the "prominent men of Snohomish" as teased by the drawing. Instead, he describes the rumbling river, the well-kept lawns, and this famous tree, "one-half mile south

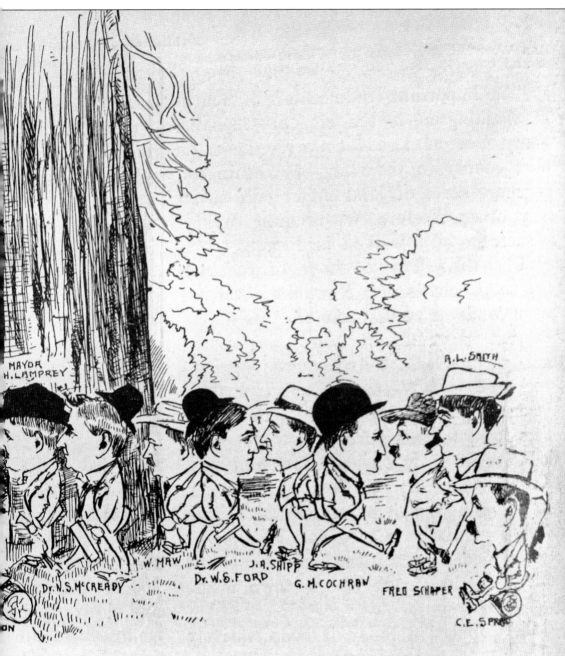

MAYOR H. LAMPREY

R. L. SMITH

Dr. N. S. McCREADY

W. MAW

Dr. W. S. FORD

J. A. SHIPP

G. M. COCHRAN

FRED SCHAFER

C. E. SPR...

...ON

...D ITS FAMOUS CEDAR TREE

of the city, and through the center of which a bicycle path has been hewn." The final paragraph reports on the industries that are filling the coffers of the owners to overflowing. The famous tree blew over in a storm in 1927, and another was fashioned to replace it, but the spirit was gone. (UW, 979.7 see v.1 No. 1–7.)

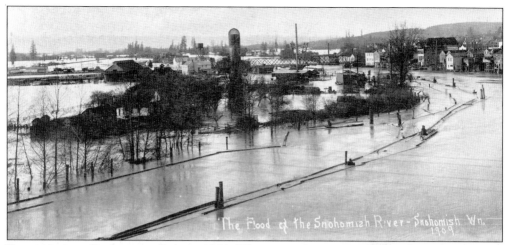

FLOOD OF THE SNOHOMISH RIVER, 1909. This image was captured from the railroad bridge over the flooded river, and it makes clear how this place evolved into a fertile river valley of rich bottomland. The tall silo belonged to the mill, and to the right of it can be made out the soon-to-be-replaced Avenue D Bridge leading into town. (FL-002.)

POSTCARD AND SNOHOMISH ADVANCE, 1917. The Christmas issue of Snohomish's third newspaper reports, "The high water . . . caused the city to become for the time being a veritable 'No Man's Land.' " This image of railroad tracks being washed out was published as a postcard, evidently a popular way of distributing the news. (FL-036.)

102

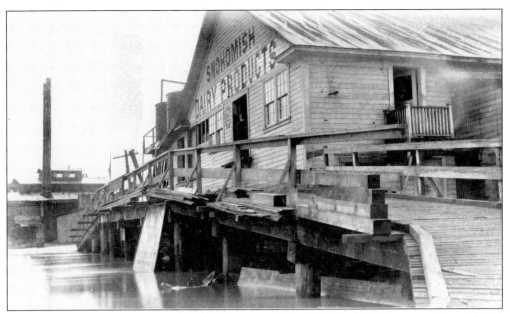

HIGH WATER, 1917. The *Snohomish Advance* story reports, "This institution was entirely surrounded by running water and had a skiff at its front door as a means for getting over the works. All week the plant was shut down owing to the river running through its boiler rooms." (BU-022.)

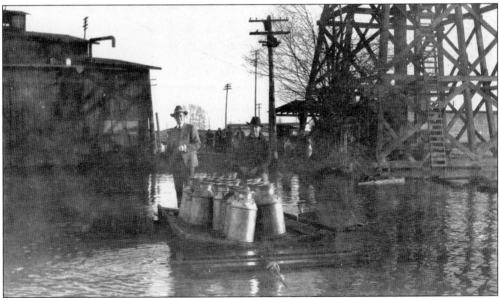

WORKING WITH THE HIGH WATER, 1917. Harley Trowbridge (left), manager of Snohomish Dairy Products, and an unidentified employee, do what they must to deliver the product. Another story in the *Advance* reported that all the stores were fully stocked for Christmas but were missing customers: "the effects of the high water [are] keeping many persons at home until the eleventh hour." (FL-015.)

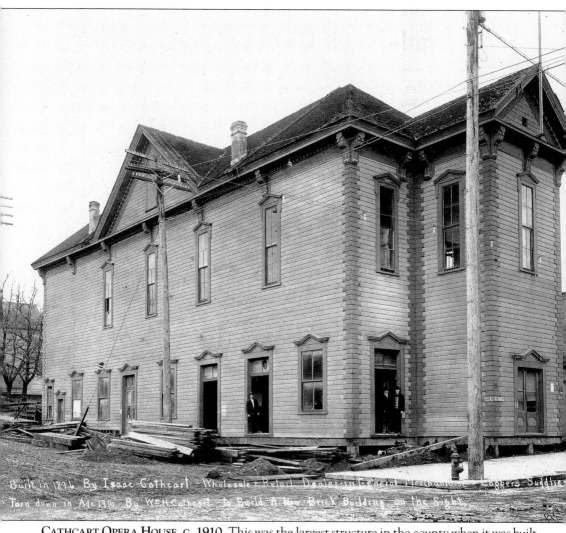

Built in 1876 By Isaac Cathcart - Wholesale + Retail Dealer in General Merchandise - Loggers Supplies
Torn down in Apr. 1910 By Wm H.Cathcart to Build A New Brick Building on the Sight.

CATHCART OPERA HOUSE, C. 1910. This was the largest structure in the county when it was built in 1876. It is shown here apparently in the process of being torn down. Standing on the corner of Avenue D and First Street, facing the river, it must have served as a totem of civilization, appearing suddenly in a clearing surrounded by a dense forest of giant trees. The second floor was used as an opera house, although it seems to have been referred to as the Atheneum Hall as well. Using either name, it was the site for many festive evenings in early Snohomish. When Cathcart went broke, the building came full circle as an empty edifice. It was replaced by a one-story building in 1910. William Whitfield writes that the cultural ambition of the Atheneum society resulted in "one of the most unique and noteworthy literary associations in the early history of Washington territory." (Picket, FS-005.)

Snohomish County Tribune

OFFICIAL CITY PAPER

VOL. XXII. SNOHOMISH, WASHINGTON, OCTOBER 13, 1911. No. 29

COSMOPOLITAN CLUB LADIES WILL GIVE MINSTREL SHOW

The Elite of Snohomish Will Play 'High Jinks'
Black their Faces and Appear Foolish
For Benefit of Club

Hon. E. C. Ferguson

SNOHOMISH TEAM WINS AT PUYALLUP VALLEY FAIR

Bring home Great Northern Cup
and many other prizes

COMMERCIAL CLUB'S GREETING TO TAFT

GAS CO. DEMONSTRATES POWERFUL ARC LIGHTS

Hon, E.C.Ferguson, Founder of Snohomish Passes Away

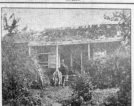

Hon E C Fergusons first residence

BIG CROWD TO SEE TAFT IN EVERETT

FIFTH COMPANY MAKES GREAT SHOWING

Residence of the late E C Ferguson

Office occupied by E C Ferguson for 23 years

***Snohomish County Tribune*, 1911.** The October 13 issue announced the death of E. C. Ferguson around 9:00 p.m. on the previous Saturday. He lived several lives—as an explorer, pioneer entrepreneur, public servant, real estate dealer, and father of three children and of one town. He was in popular demand as a toastmaster in his later years, when, after a few glasses of sauterne, he would regale his audiences with stories of early Snohomish. Asked once why he started a new county, he replied that with so many politicians in the area it was wiser to form another county than to kill a politician. Ferguson was 78 years old.

POSING ON THE NEW BRIDGE. This photograph is from a family album grouped with others of the same unidentified woman posing before structures new to Snohomish—the Carnegie Library Building (1910) and the new Avenue D Bridge, pictured here. The grand opening for the new steel bridge was September 19, 1911, almost a year late. The steel didn't arrive at the Moran Ship Builders in Seattle until June 23, 1911. But by August, three air hammer crews were on site, hot-riveting the steel members together. Each air hammer required three men—one to heat the rivet and then throw it to the "catcher," while a third man operated the hammer. This new way of building things in Snohomish must have drawn quite a crowd down to the riverside to watch, and to speak a little "Kodakery" with each other. Kodak cameras had been available since 1895.

Seven

A NEW BRIDGE

Noble Harvey purchased the county's first Ford automobile in downtown Snohomish when he was 37 years old and drove it home over the new Avenue D Bridge, built of steel in 1911. Noble had a reputation for being first. In 1873, he had been the first white male to arrive in the county by way of childbirth to two white parents.

Immediately across the bridge was the lumber mill, where one still operates today. In fact, a mill has operated on this part of the Harvey claim since 1866. In 1909, Noble sold the land to the Cascade Lumber and Shingle Company for $16,000. The sticker price for a Model T Ford in 1911 was under $1,000—around $22,000 in 2006 dollars.

Across the street from the mill, to the west, was Harvey Park, a baseball field with seating for 500 people. Noble made the land available in 1903 and sold shares to an impressive list of the town's leading citizens to finance it. In May 1911, the ballpark was the site of the first airplane flight in the county, when a Curtiss-Farman-Wright biplane took off. The ballpark was also the site of the first airplane crash in the county, moments later.

Following the river road west for a bit, Noble could have stopped by Snohomish Dairy Products to show off his new car. The company had recently purchased two and a half acres from Noble, who had gotten out of the diary business but held a small financial interest in the new company. Since 1895, he had kept a rather large herd of cows, selling milk door-to-door. It seems Noble was the first milkman of Snohomish.

Returning home, Noble would have crossed the railroad tracks running east-west, laid in the early 1890s by the St. Paul, Minneapolis, and Manitoba Railway. The John Harvey estate received $7,000 for its appropriated land, some of which went to Noble, who was 20 years old at the time. That is when he first began lending money to friends in need.

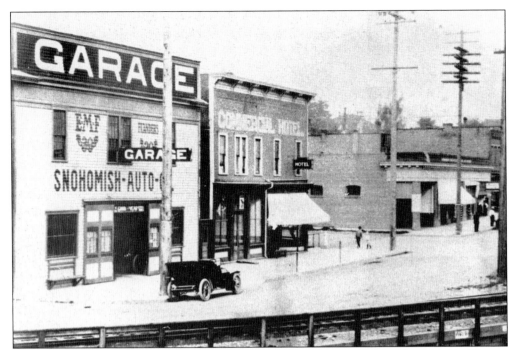

SNOHOMISH AUTO COMPANY, C. 1911. Snohomish Auto is probably where Noble Harvey purchased the first Ford in the county. The Commercial Hotel next door is gone, as is the garage, but across the street, the one-story building that replaced the grand old Cathcart Opera House and Atheneum Building is still in use. (Courtesy Forrest Johanson.)

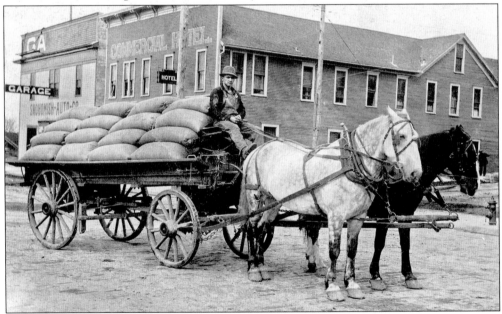

JOSEPH STEUBER DELIVERING WHEAT, C. 1911. This image is a reverse view of the same corner, First Street and Avenue D, this time looking northwest. Note the modern fire hydrant on the right, which replaced the original urban fire protection system of placing fire hose carts around town. A water main was installed on First Street in 1892 (see page 77). (BU-072.)

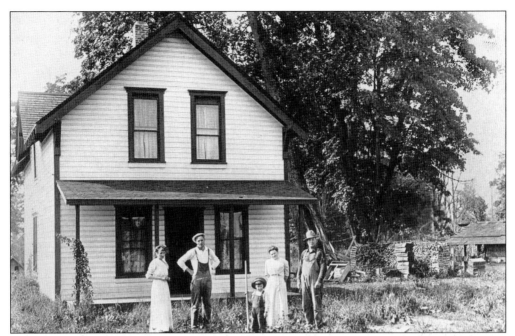

HARVEY HOME, 1906. This is the house that Noble built, but he meant it to be a barn. From left to right are Maude Wheeler, Bunny Bunstead, a young Eldon Harvey, Edith White Harvey, and Noble. Eldon also raised his family in this house, which is still standing but now offers a close-up view of takeoffs and landings at the Harvey Airfield (1944) from its back door.

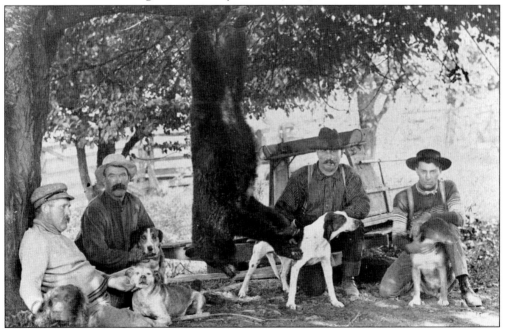

SUCCESSFUL BEAR HUNT, C. 1900. The historical society has several shots of bear hunters posing victorious. It was evidently a popular activity, which is probably one reason why there are no bears in the Snohomish area today. From left to right are Lon Morgan, Hank Mulholland, Noble Harvey, and George Merz. (Courtesy Donna Harvey.)

Sheet 25 from Plat Book of Snohomish County, 1910. This was published by the Anderson May Company of Seattle. Both sheets, shown here on facing pages, are incredibly detailed maps of the Snohomish area, showing individual property boundaries labeled with the owner and the number of acres.

SHEET 26 FROM PLAT BOOK OF SNOHOMISH COUNTY, 1910. The grid is composed of 4-inch squares each representing 1 square mile. Double lines indicate a wagon road, a broken line means a foot trail, and railroads are indicated with the traditional symbol for tracks. (UW, G1488.S6 A52 1910.)

111

SNOHOMISH POST OFFICE, C. 1911. The post office was located in the corner space of the new Blackman Building (note H. Blackman's house peeking out from behind, on the right). The office featured a historic portrait of Abraham Lincoln received by the first postmaster, E. C. Ferguson, who was appointed during the Lincoln administration in 1863, when Ferguson's Blue Eagle Saloon served as the first post office. The local mail arrived once a week by steamship, and mail from the East Coast arrived once a month via San Francisco, or by chance with a traveler heading this way. Lot Wilbur was appointed postmaster in 1877, and the post office moved to Wilbur's drugstore. With the increase of settlers upriver, the government authorized Wilbur to hire the county's first mail carrier, a job that paid $600 a year. W. W. Pettit was appointed in 1884, and mail delivery went from three times a week to daily, but not without a citizens' petition. The age of modern mail delivery approached with the first train, arriving in 1889. (BU-064.)

POSTCARD OF POST OFFICE INTERIOR. Arthur Blackman was the postmaster when the office moved to the Blackman Building around 1902, before being burned out in May 1911 (see page 97). But it was quickly rebuilt, and the post office moved back within the year, most likely with a similar interior layout. (BU-063.)

REVERSE, POSTMARKED 1907. Home delivery began in 1911. A city ordinance directed that every structure must display a number and that a proper receptacle be available to receive the mail, or that a slit be cut in the door to slip the mail through. It took only two carriers, Albert Love and Robert Hazeltine, to deliver the mail twice a day.

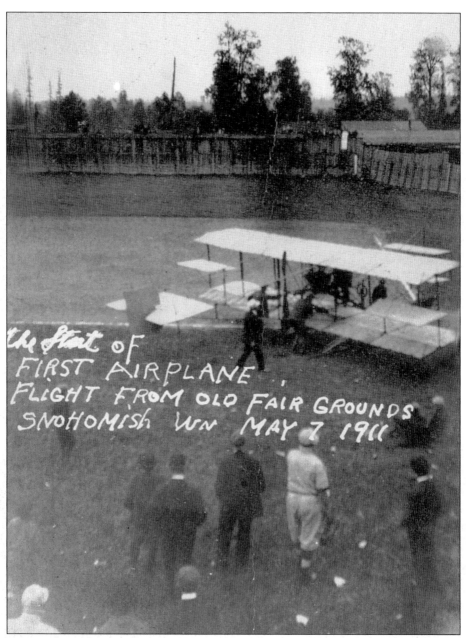

FIRST AIRPLANE FLIGHT, 1911. A full-page advertisement appeared in the May 5, 1911, issue of the *Tribune* promising "the sensation of the hour." Fred J. Wiseman, the "World's Greatest Aviator," would fly in a Curtiss-Farman-Wright biplane, "The Fastest Machine in the World," at Harvey Park that Saturday and Sunday at 3:00 p.m. In smaller print at the bottom was, "Admission $1.00; You Cannot See the Machine Start and Land Unless You are Within the Grounds." Wiseman, from California, had been flying only a year but had already run up the longest sustained flight, of more than six minutes. In fact, he had an accumulated time of 49 minutes, 43 seconds in the air. He also carried mail between Petaluma and Santa Rosa, a feat considered the first airmail flight in U.S. history. He flew the same plane that he brought to Snohomish, and today it hangs in the Smithsonian Institution in tribute to that first airmail flight. (Douglas, AV-002.)

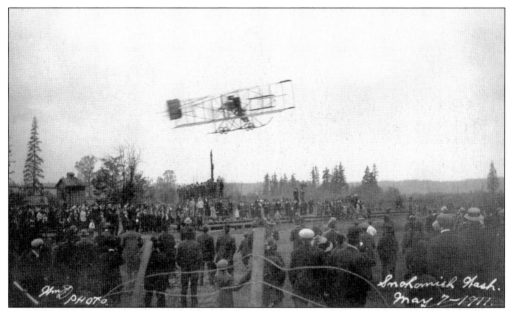

FLIGHT. Wiseman's airplane was a hybrid that combined features of the pusher/canard-type biplanes built and flown by the Wright brothers, Glenn Curtiss, and the French aviator Henri Farman. The wingspan measured 33 feet, and the two wings added up to 400 square feet of wing surface. Power was provided by an 80-horsepower V-8 engine, driving an 8-foot pusher prop at 1,200 revolutions per minute. (AV-001.)

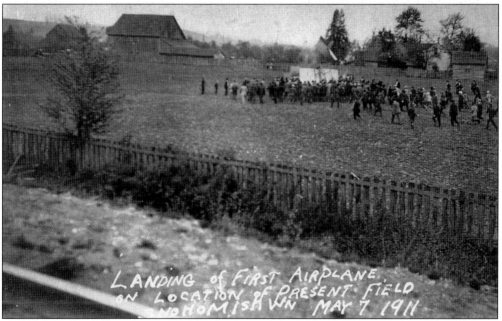

LANDING. Two days of continuous rain soaked the ground and the fabric wings of the biplane, making it extra heavy. Not wanting to return the $410 in paid admissions, Wiseman took off, reaching an altitude of 60 feet before the engine quit and the plane nose-dived into the muddy ground. He walked away and went on to successful flights in Olympia later that month. (AV-003.)

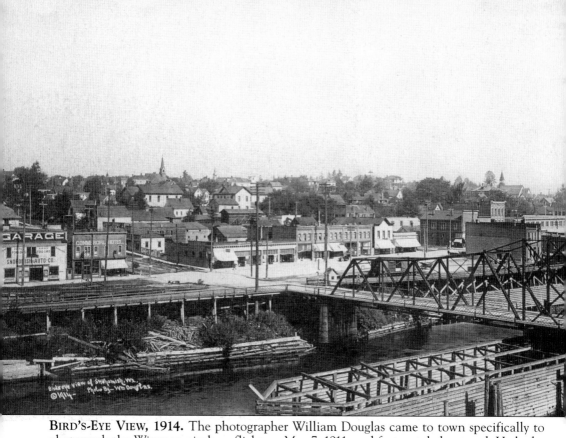

BIRD'S-EYE VIEW, 1914. The photographer William Douglas came to town specifically to photograph the Wiseman airplane flight on May 7, 1911, and fortunately he stayed. He had a room on First Street when the big fire broke out later that month, when he captured the striking images featured in the previous chapter. Douglas's bird's-eye composition here is centered on the intersection of First Street and Avenue D, with the new steel bridge entering from the right. On the north side of First Street, at the corner, is the one-story building that replaced the Atheneum/Cathcart Building, which is still in use. Next door is the former Brunswick Hotel, now an apartment building. The bridge swung on a center mechanism, which is protected by the impressive wooden structure. The Milwaukee railway track paralleled First Street, and where it crossed Avenue D, a guard, with his little house, was needed to prevent daydreaming citizens from crossing in the path of a moving train. The depot, fashioned out of the former Wilbur building, is seen on the right. (Douglas, FS-026.)

LOOKING EAST, C. 1910. Because this photograph comes without notation on the reverse, one is free to imagine why the two children are posing for the camera in the busiest intersection of early Snohomish, First Street and Avenue D. The long shadows and covered hands describe a winter afternoon in this image taken after 1910, since that's when the structure on the left was built to replace the Atheneum/Cathcart Building. Further, the viewer should be able to make out the Carnegie Library Building, standing in the sunshine at the horizon—it was also built in 1910. The gift of this image is that it helps one to understand, visually, the magnitude of the community achievement in obtaining a $10,000 award from the Carnegie Foundation to build such a grand building at the top of its humble main street. They did it for the children. (FS-030.)

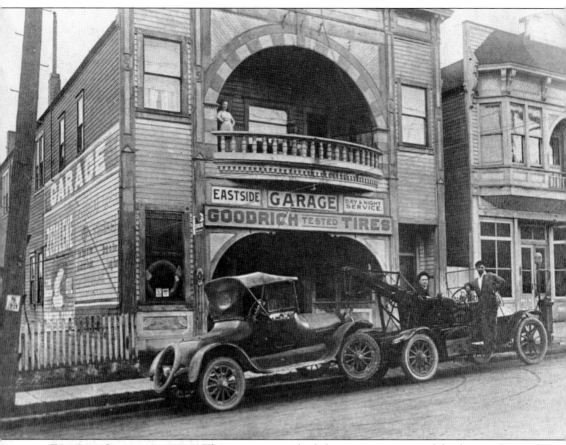

EASTSIDE GARAGE, C. 1915. The structure on the left is a rare survivor of the frontier box-style theater era. Built in the boom year of 1892 as the Alcazar Opera House, it had a storefront saloon and a theater seating 300 patrons on two levels. The horseshoe balcony featured private boxes in its early bawdy days, but by the start of the 20th century, it was used for community productions, as well as professional touring shows, including a young Al Jolson in 1906. The Crippen family, members of which may be posing for this picture, purchased it, and the end of the First World War had recast the delicate ingénue of a structure as the first garage to service the horseless carriage. Around this time, with the balcony opening floored over, the second floor was divided into inexpensive apartment units sharing a central bathroom. In 2007, sections of linoleum and period wallpaper are all that remain since its new use is as storage for the junk store on the first floor. Its gorgeous neighbor split the scene long ago. (BU-042.)

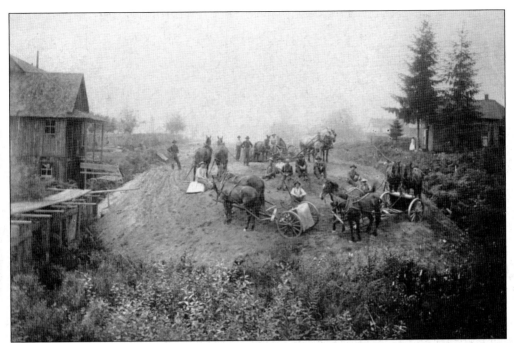

WORKING ON THE GULCH. A 30-foot-deep gulch ran down the middle of the Snohomish town site, carrying overflow from Blackman Lake to the Snohomish River. This early photograph notes on the reverse that the crew is working on Fourth Street, probably where a bridge was eventually built between Cedar and Maple Avenues. The men have stopped adding fill to pose for history—and it is appreciated. (SG-022.)

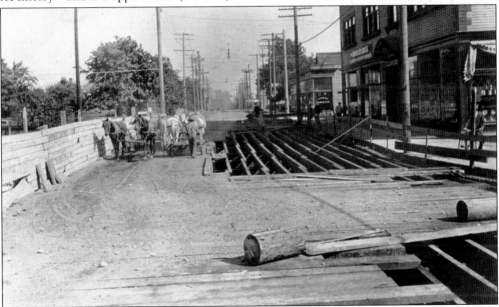

BRIDGING OVER THE FIRST STREET GULCH. Here a crew is bridging over the gulch at First Street and Union, in front of the Eagles Hall, which was dedicated with a grand ball for 1,000 in 1906. The view is east, so the gulch continues toward the river on the right, behind buildings on First Street, west to Avenue A, where it disappears into a modern culvert. (Gee, FS-021.)

NORTH SIDE OF FIRST STREET, C. 1911. From the left to just beyond the center of this image, the buildings are all occupied in 2007. The three-story brick building was responsible for stopping the fire on May 30, 1911. Scotty Connellys, next door, reopened his saloon in a tent immediately after the fire in order to serve his customers from a "dry" Everett. (FS-074.)

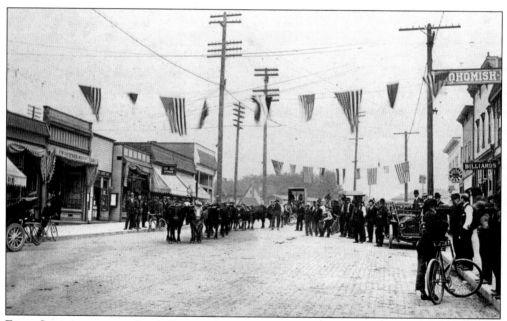

FIRST STREET WITH AN OXEN TEAM. This photograph had to have been taken after 1910 since the distinctive roof of the Carnegie Library can be seen on the horizon on the right. The view is northeast, and none of the buildings on the north side have survived; gone too are the oxen teams parading down First Street or pulling logs out of the forest. (PA-050.)

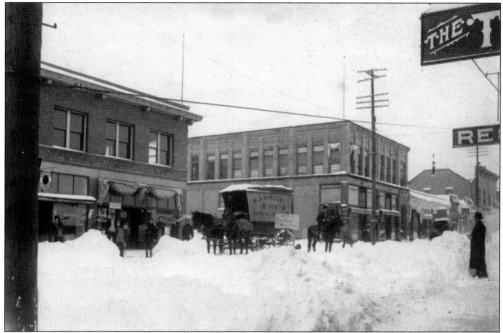

RECORD SNOWFALL, LOOKING EAST, 1916. This view is at the intersection of First Street and Avenue B. That is the Otten Store in the center, still standing but better known today as the Marks Building, named after Tom Marks, a pioneer real estate agent who took back the building when John Otten defaulted on his mortgage. (Snohomish Studio, SN-003.)

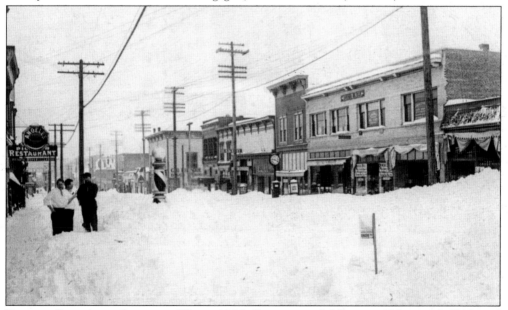

RECORD SNOWFALL, LOOKING WEST, 1916. Snow started falling on February 4, 1916, and continued for three days, breaking all records, until it measured around 40 inches, carefully calculated by Lot Wilbur. The view shows the north side of First Street between Union Street (right) and Avenue A, at about the center of the picture. This block of buildings is still intact and occupied. (SN-010.)

POSING INSIDE THE CARNEGIE LIBRARY PLANTER, C. 1915. This feature of the 1910 building was lost to a 1968 addition. It has been thought, from wider views, that this architectural element was a fountain. So this image settles that question; plus it shows how much fun it was to go to the library in early Snohomish. (PE-490.)

POSING OUTSIDE THE CARNEGIE LIBRARY PLANTER, C. 1915. This is another snapshot from the family album of Winifred Moran and her sister Marguerite. The existence of a Carnegie Library in this small town is a living testimony to the determination of the women leaders of early Snohomish. They applied twice to the Carnegie Foundation for funding, the second time with E. C. Ferguson and Sen. Sam Piles's help.

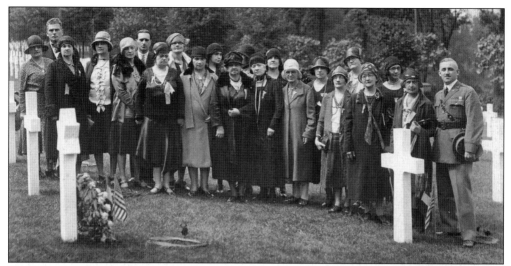

WASHINGTON STATE MOTHERS IN FRANCE, C. 1918. After World War I, people all over the country, led by the mothers who lost their sons in France, demanded that our government return the boys' bodies to American soil. Instead, the government paid for the mothers to visit their sons' graves in France. Anna Davis from Snohomish is the eighth person from the left. (MI-035.)

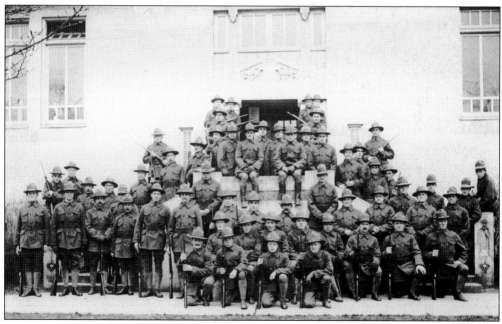

COMPANY D AND THE CARNEGIE LIBRARY. Gathered for the camera at the entrance to the library is Snohomish's Company D of the National Guard. This company replaced the 5th Company as the state guard when the latter left Snohomish for the war. A reunion was held in 1937 at the Masonic Hall for both companies, and 56 veterans attended. (MI-048.)

RIVER ROAD, LOOKING EAST, C. 1910. This road follows the river on the south side connecting Snohomish with Lowell, then on to Everett. It is still well used but looks quite different since the road has been raised to avoid high water. It might be the Holcomb family sitting out on the porch. (RI-031.)

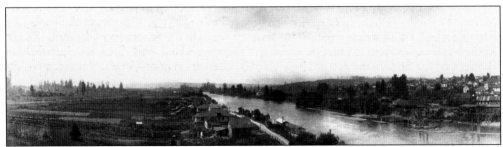

LOOKING WEST FROM SNOHOMISH. South of the river the land is as flat as a tabletop, stretching across the valley floor as far as the eye can see. The rich farmland lies largely fallow in 2007, except for a corn maze, a nursery growing trees for landscaping, and a turf farm with a driving range for golfers. (SG-021.)

AFTERWORD

From the *Snohomish County Tribune*, 1927:
"And Still They Don't Know How We Were Named."

New and different interpretations of the meaning of the Indian word "Snohomish" were received this week from Snohomish pioneers while others corroborated the views given in last week's issue of the *Tribune*.

Mrs. L. D. Stokes, 417 Ave. D, has a plausible explanation of the word. It is her belief the word means "meeting of the waters." Mrs. Stokes adds, "This meaning is derived because of the confluence of the Pilchuck and Snohomish rivers a short distance above the town site."

Mrs. Fred Hume, Maple St., believes the word to mean, "snow water people." In explanation of this Mrs. Hume added that Skykomish meant "high water people."

Mayor C. H. Bakeman, resident of Snohomish for nearly fifty years, states that the word signifies "gathering of the people." Mr. Bakeman said that was the interpretation handed down by an Indian medicine man who resided on the riverbanks below Snohomish nearly half a century ago. It was the custom, added the mayor, to name towns after events, and this meant there had been an important meeting here.

M. R. Cleveland, 705 Lincoln, corroborated the opinions of others in his statement that it meant "white water."

From *Snohomish County: An Illustrated History* (2006), page 24:
(Provided by Tulalip Tribes Cultural Resources Center)

In pre-treaty Snohomish County, four main groups of people lived along the river courses between the Cascades and the Sound: the Snohomish (*sdhub_*, a name possibly related to the Lushootseed language word for *man*, *stub_*), whose subgroups include the Skykomish (Upriver People), the Monroe People (*sdutuhub_*, a name probably related to *sduhub*), and the Pilchuck People (Red River People [*Pilchuck* means *red water* in Chinook jargon]); the Snoqualmie (the Moon People, whose name comes from the mythic account of their beginnings); the Sauk and Suiattle River People; and the Stillaguamish (the River People). The *–amish* and *–omish* suffixes mean *people*, and the *–mie* suffix means a *homogenous group* or *cluster*.

Descendants of the Snohomish People live on the Tulalip Reservation.

BIBLIOGRAPHY

Cameron, David A., ed. *Snohomish County: An Illustrated History*. Index, WA: Kelcema Books, 2005.

Dilgard, David. "The Adventures of Old Ferg, Parts One and Two." *Journal of Everett and Snohomish County History*. Everett, WA: Everett Public Library, 1981–1982.

History of the Pacific Northwest: Oregon and Washington. Portland, OR: North Pacific History Company, 1889.

Kiblinger, Charles. "Snohomish River orthophotos—1938." Seattle, WA: Univeristy of Washington, 2003.

Monroe, Robert D. "Sailor on the Snohomish (Extracts from the Van Buskirk Diaries)." *Journal of Everett and Snohomish County History*. Everett, WA: Everett Public Library, 1984–1985.

Northern Star. Snohomish, Washington: 1876–1878.

The Online Encyclopedia of Washington State History. HistoryLink.org

River Reflections, Part I: 1859–1910. Snohomish, WA: Snohomish Historical Society, 1976.

River Reflections, Part II: 1910–1980. Snohomish, WA: Snohomish Historical Society, 1981.

Schuler, Lynda Hansen. *And We Will Not Forget: History of the Snohomish School District, 1866–1994*. Snohomish, WA: Snohomish School District, 1994.

Snohomish Advance. Snohomish, WA: 1917.

Snohomish County Tribune. Snohomish, WA: 1906–1938.

The Snohomish Eye. Snohomish, WA: 1883.

The Snohomish Story, From Ox Team to Jet Stream, 1859–1959. Official Program, Snohomish Homestead Centennial, 1959.

Whitfield, William, ed. *History of Snohomish County*. Seattle, WA: Pioneer Historical Publishing Company, 1926.

INDEX

ACROSS AMERICA, PEOPLE ARE DISCOVERING SOMETHING WONDERFUL. *THEIR HERITAGE.*

Arcadia Publishing is the leading local history publisher in the United States. With more than 3,000 titles in print and hundreds of new titles released every year, Arcadia has extensive specialized experience chronicling the history of communities and celebrating America's hidden stories, bringing to life the people, places, and events from the past. To discover the history of other communities across the nation, please visit:

www.arcadiapublishing.com

Customized search tools allow you to find regional history books about the town where you grew up, the cities where your friends and family live, the town where your parents met, or even that retirement spot you've been dreaming about.